IMAGES
of America

ALBANY REVISITED

On the cover: Here is a busy northeast corner at North Pearl Street and State Street in 1912. North Pearl and State Streets have always been central to Albany's success. Originally lined with Dutch houses as depicted in many James Eights paintings of the early 19th century, these two streets have undergone a continuous evolution conforming to the times. Today it is once again a thriving area with retail and commercial space serving the community. (Courtesy of the New York State Public Library.)

IMAGES
of America

ALBANY REVISITED

Don Rittner

ARCADIA
PUBLISHING

Published by Arcadia Publishing
Charleston SC, Chicago IL, Portsmouth NH, San Francisco CA

Printed in the United States of America

Library of Congress Catalog Card Number: 2007941605

For all general information contact Arcadia Publishing at:
Telephone 843-853-2070
Fax 843-853-0044
E-mail sales@arcadiapublishing.com
For customer service and orders:
Toll-Free 1-888-313-2665

Visit us on the Internet at www.arcadiapublishing.com

*Dedicated to Adriaen Block, Adriaen Van der Donk,
Arendt Van Curler, James Eights, John Wolcott, and Lou Ismay.*

CONTENTS

ACKNOWLEDGMENTS

Many people have graciously provided photographs or information for this book. I would like to thank Mike Engle; Vince Martonis and Hanover History Center of Silver Creek, New York; Tom Clement; Library of Congress; Coulson and Wendt; and Marieke Leeverink. Much of the great history of the Albany Senators came from the excellent Web site of David Pietrusza (www.davidpietrusza.com/index.html).

Special thanks go to Ellen Gamache from the Albany Public Library and Chris Hunter, archivist with the Schenectady Museum Archives, for allowing the use of their excellent collections. I am indebted to Rebekah Collinsworth and Pam O'Neill and all the great folks at Arcadia Publishing.

INTRODUCTION

There's no city like Albany. It was Henry Hudson who explored the area in 1609, but it took a handful of Dutch merchants to settle the region with a small trading fort in 1614. The city has been making history every since.

Albany is located about 150 miles north of New York City on the western banks of the Hudson River, or as the original inhabitants, the Mohicans, called it, *Muh-he-kun-ne-tuk*, meaning "the river that flows both way."

With less than 100,000 people living here today, Albany has transformed itself into a city specializing in education and politics. There are a dozen colleges and universities in law, art, and medicine, to name a few, and you can get a degree in almost any subject area. Albany has always had politics in its blood. It was here that the struggle between the Dutch and English during the 17th century came to a head in 1664. It was in Albany that Benjamin Franklin delivered his plan of union in 1754, and the city became the capital of the state in 1797. More than 25 percent of the population today works in government.

During much of the late 19th and first half of the 20th century, entire blocks of homes and businesses were razed to build impressive government buildings like Albany City Hall, the New York State Capitol building, New York State Education Building, State Hall (the Court of Appeals), State Geological Hall, the Alfred E. Smith State Office Building, and the Nelson Rockefeller Empire State Plaza.

Of course there is more to Albany's history than politics, and this book will help you explore the city's early 20th century by viewing its interesting architecture, landmarks, streetscapes, and views, through the more than 200 photographs in this book. However there is one special chapter in *Albany Revisited*.

For nearly 75 years, Albany had a professional baseball team. Throughout their history the Albany Senators were affiliated with several major league teams including the Cincinnati Reds, 1938–1939; Pittsburgh Pirates, 1940–1950; Boston Red Sox, 1952–1954 and 1956–1957; and the Kansas City A's, 1958–1959. The played at Hawkins Stadium, built in 1928 and located in Menands, a northern suburb of Albany. The Senators played in a few different leagues: the New York State League in 1885; Eastern Association in 1891; Eastern League in 1892–1893 and 1896; New York State League in 1899–1916; Eastern League in 1920–1932; International League in 1932–1936; New York-Penn League in 1937; and Eastern League in 1938–1959.

Originally the Senators were members of the New York State League and won pennants in 1901, 1902, and 1907. The city went without a game for a few years when the New York State League ceased to exist in 1917, but by 1920, they replaced the Providence Grays in the Eastern League and continued there until that league ended in 1932. Albany won flags in 1927 and 1929.

From 1932 to 1937, Albany played in the International League and then moved over to a new Eastern League, where it stayed until they disbanded in 1959. They finished first in 1942, 1949, and 1952, but lost in the play-offs each time before winning the championship in 1954.

In 1960, the Eastern League reduced the number of teams from eight to six, and Albany was eliminated. The team disbanded and the stadium went up for auction for back taxes and was torn down. All that remains now are the history of the team shown here through more than 80 photographs. Albany has made several attempts to bring back baseball starting in 1983, but it has never taken off like the days of the Senators.

I remember as a young boy exploring the abandoned Hawkins Stadium with my friend Paul Klink. We climbed to the roof over the grandstands and then explored the outfield and infield. The old team bus was still in the garage and thousands of season tickets were sprinkled along the garage floor. As Paul and I stood at the pitcher's mound, we heard the crack of a bat, the roar of a crowd, and the announcer over the address system. We ran like the dickens and never looked back. It was torn down the next day.

So enjoy this book, as it shows the transformation of the city's main thoroughfares and neighborhoods disappear to make room for the growing importance of Albany as a state capital during the first half of the 20th century. Fortunately through the lens of photographers, we can relive these historical moments.

Don Rittner
January 2008

One

OLD ALBANY

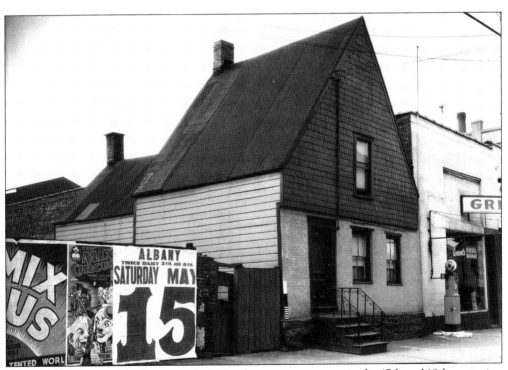

Dutch-gabled homes, like this one at 922 Broadway, were common in the 17th and 18th centuries. This home was built in 1734 and demolished in 1943. There are no examples of Dutch homes like this anywhere in the city today. Notice that the Tom Mix Circus was coming to town. Tom Mix, a cowboy movie star, joined the Sells-Floto Circus in 1929. He died on October 12, 1940, in a car crash, making this photograph taken sometime between 1929 and 1940.

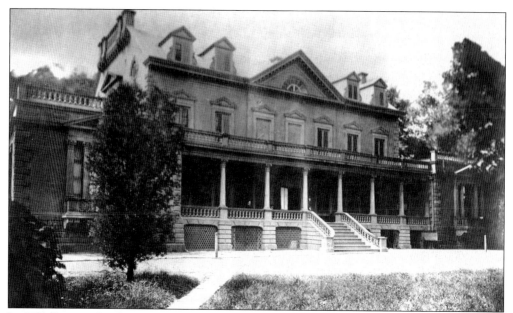

In 1765, Patroon Stephen Van Rensselaer II erected this manor house, located off Broadway near Menands. It was a large brick structure, almost 46 feet deep. Son Stephen Van Rensselaer III lived at the mansion for many years and was one of the founders of Rensselaer Polytechnic Institute (RPI), the first science college in America in 1824. The mansion was removed to the campus of Williams College for a fraternity house and later demolished.

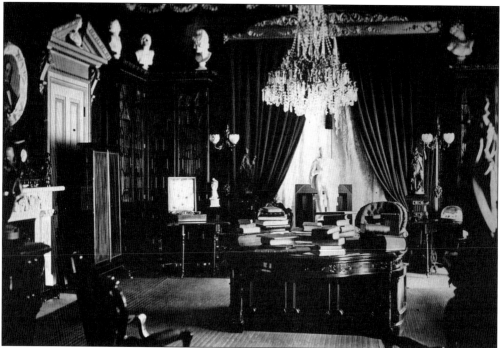

Here one can see the lavish drawing room of the Van Rensselaer Manor, built in 1765. The mansion was demolished in 1973. Architect Marcus Reynolds is the culprit who brought the mansion to his alumni college, Williams College in Massachusetts, where it eventually suffered its fate.

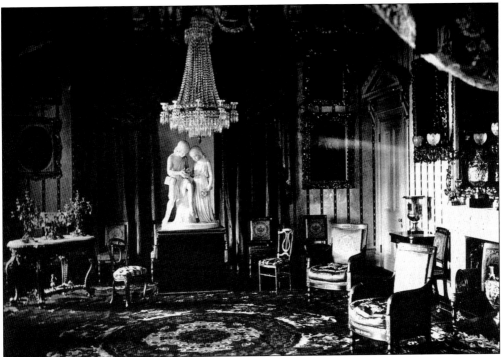

The library of the Van Rensselaer Manor appears to be as lavish as the drawing room and probably all the rooms of this mansion. Many of the foundation blocks of the mansion are actually laying on the grounds of the RPI Technology Park in East Greenbush. A former college president had plans to reuse them but it fell through.

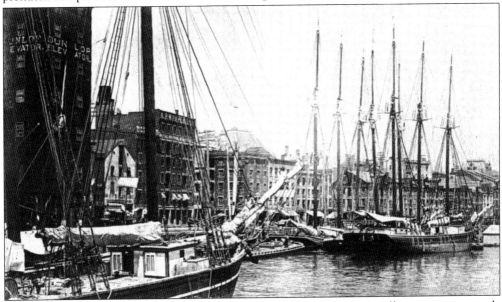

This river view, from around 1900, shows that the Hudson River was still an important trade and transportation corridor at the beginning of the 19th century. Several sloops are seen at port. The government building roof can be seen in the background, and many stores and warehouses line the dock. Interstate 787 has obliterated this scene.

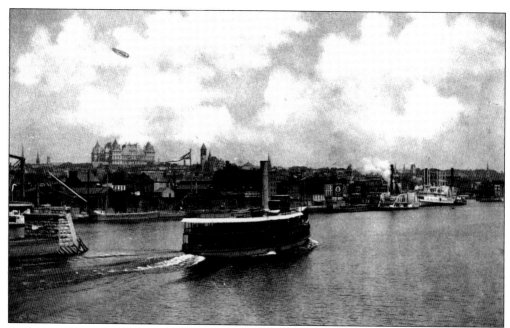

A Hudson River day liner is seen here as it exits from the Greenbush Bridge and headed for Steamboat Square. This c. 1900 river view shows the capitol building, Albany City Hall, and the Government Building (post office) and many warehouses. The day and night liners are docked along the river near where the present D&H (Deleware and Hudson) building sits. The old ticket office still stands.

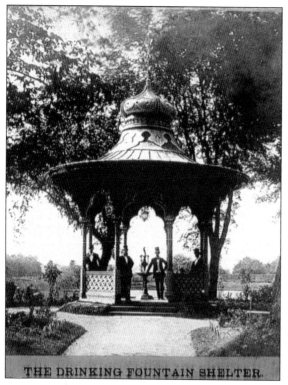

THE DRINKING FOUNTAIN SHELTER.

The drinking fountain at Washington Park, around 1910, no longer exists but served 19th-century parkgoers well. The park was developed in 1871 and today is the center for many public activities. During the 1970s, hippies and others enjoyed weekly music concerts in the park.

Two

VIEWS AND VISTAS

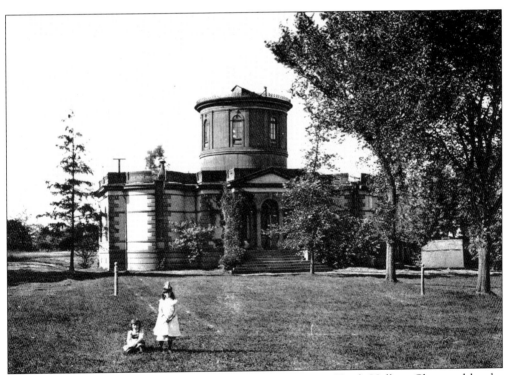

This is a view of the first Dudley Park and Observatory near Tivoli Hollow. Chartered by the State of New York in 1852, Dudley Park and Observatory is the oldest independent organization in the country supporting research and education in astronomy and the history of astronomy. The organization celebrated its 100th anniversary in 2007. This building burned on May 16, 1904.

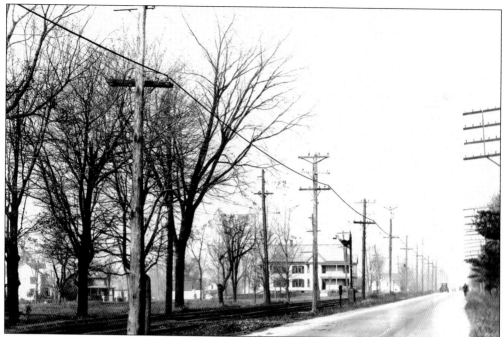

The Albany-Schenectady Turnpike, now State Street (Route 5) and Centra Avenue, was built in 1799 to connect the two cities. A railroad was also planned in the early 19th century but never materialized. Later the trolley ran down the side of the road. Today it is a busy paved highway with mostly commercial enterprises lining both sides of the road.

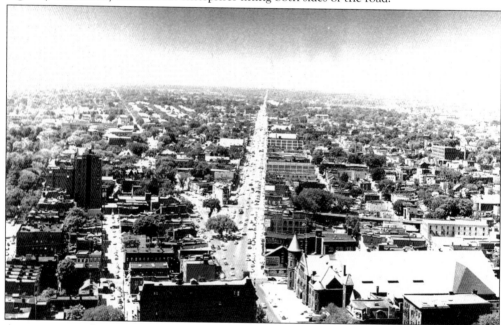

A great view to the west from the Alfred E. Smith State Office Building shows Central Avenue (Albany-Schenectady Turnpike, Route 5) on the right with the intersection of the Great Western Turnpike (Western Avenue) built in 1799, on the left, around 1930. Today the flat western sand plain is dotted with high-rise structures.

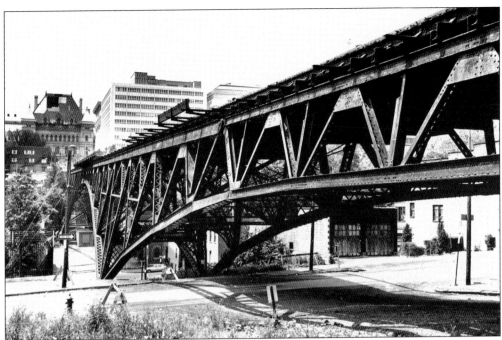

The Hawk Street Viaduct was built between 1889 and 1890 by Albany's Hilton Bridge Construction Company and was located one block north of the state capitol. It became a pedestrian bridge from 1968 to 1970 and then was dismantled by the city in July 1970. This was the first appearance of a cantilever arch bridge.

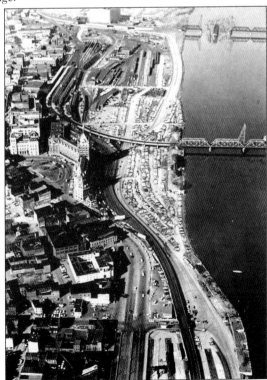

An aerial view of the west shore of the Hudson River and the city, around 1950, shows the city still connected to the river. The Maiden Lane train bridge can be seen in the foreground. Shortly after, most of the river section was turned into the Interstate 787 road system and separated Albanians from their river roots.

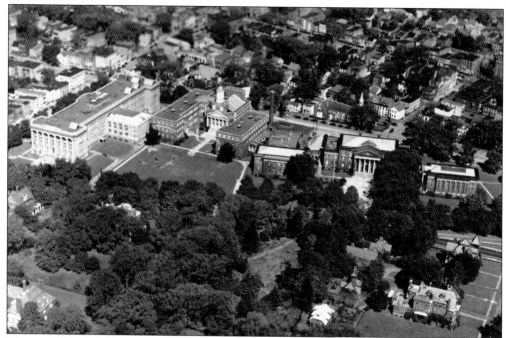

Here is a 1950s aerial view of the State Teacher's College, now the State University of New York (SUNY) at Albany. The campus is located between Madison and Western Avenues. Originally started as the State Normal School on State Street in 1884, it is still used by the university as the Rockefeller Institute of Government.

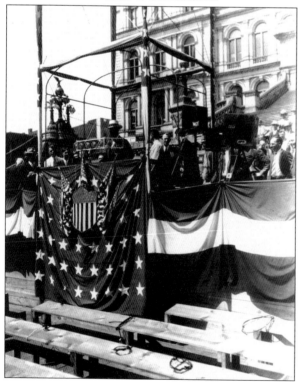

This is a photograph of the rehearsal of the first remote television broadcast in the world. New York governor Al Smith was accepting the Democratic nomination for president this day on August 22, 1928. The story goes that the rehearsal was fine with no difficulty, but that rain moved the actual event indoors, where the lack of light produced a dull picture.

Here is an early view of one of the winding roads in Washington Park as it leads down to the Park Lake House around 1930. The Spanish Revival building with outdoor stage was designed by Albany architect J. Russell White. The interiors are elaborately detailed with pink terrazzo floors, green terrazzo baseboards, pilasters, and wrought-iron chandeliers. Today it is used during summer months for different theatrical performances. It was built in 1876.

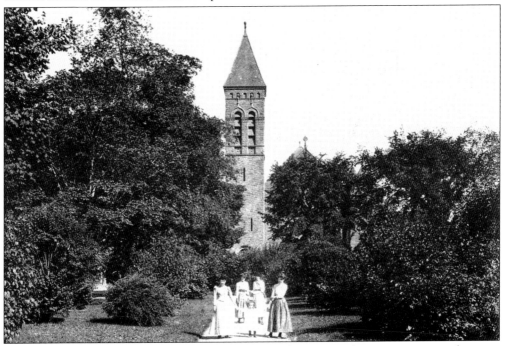

Here is a view of Washington Park showing young girls enjoying the summer among the trees. Washington Park was opened to the public in 1871 and was created from a former burial ground, parade ground, and residential street.

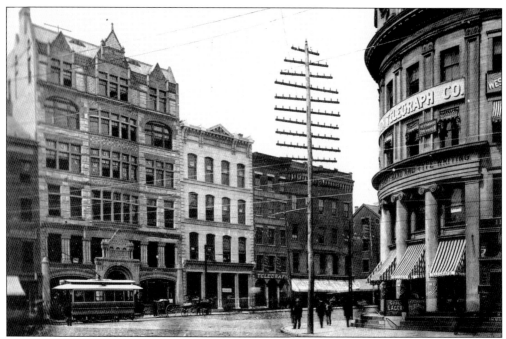

Here one can see a changing intersection, as this view looks southwest at the corner of State Street and Broadway around 1910. The Hampton Hotel on the left was built in 1906. The building to the right originally was the Albany Museum, then Western Union Telegraph in this photograph, and has been modified over the years. The trolley was going to Lark Street.

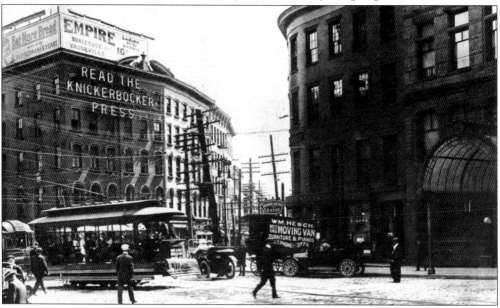

This is another view looking southeast at State Street and Broadway around 1900. Notice the open trolley and early moving truck (West End Moving). The Knickerbocker Press and other buildings on the block were razed for the D&H building and park in 1915. The billboards advertise eating bread with Fleischman's yeast and that all ladies were welcome to the Empire Theater.

Three

STREETSCAPES

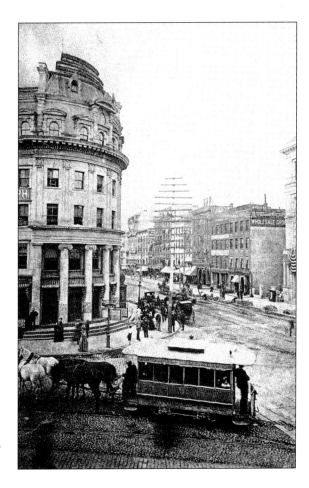

The Albany Museum building at
the northwest corner of State Street
and Broadway was built in 1855 and
replaced in 1904. The horse-drawn
trolleys began in 1863. This trolley,
No. 31, is headed to the "New Capitol,"
and dates to about 1900.

The Albany Exchange was located on the northeast corner of State Street and Broadway and was built in 1836. Later it served as the National Exchange Bank in 1885. It was demolished in 1875 to make room for the government building.

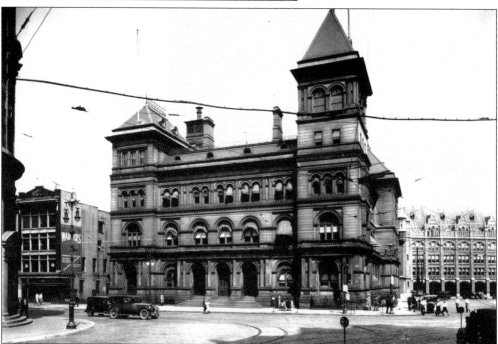

The government building on the northeast corner of State Street and Broadway replaced the Exchange Building and opened in 1883. The post office was located here. It is now used by the SUNY central administration for offices and is connected to the nearby D&H building.

Here is a snapshot of an Albanian taking a stroll north on Broadway near the government building on May 26, 1900. On the opposite side of the street stood Larkin's Music House and the Ritz Lunch, both popular stops.

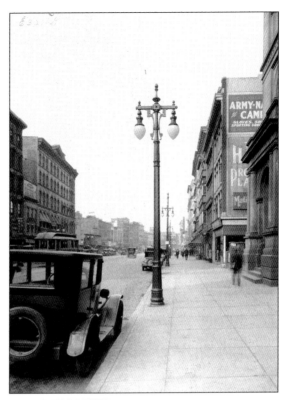

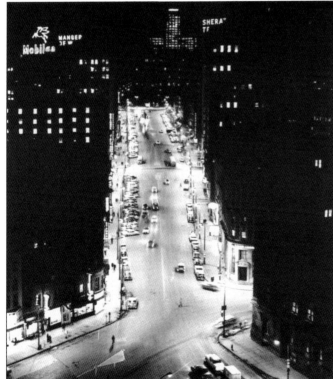

Here is a view looking west up State Street from the towers of the D&H building on August 14, 1961. At the top, one can see the lights on at the Alfred E. Smith State Office Building. Albany had an active nightlife then.

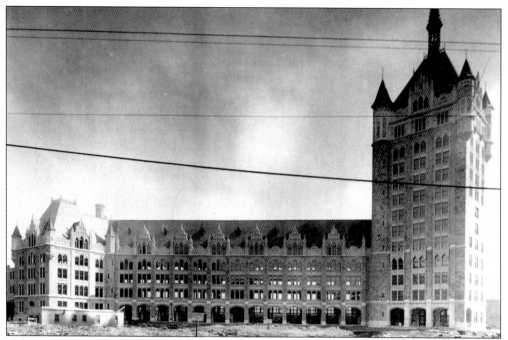

The construction of the D&H building in 1915 on Broadway, south of State Street, removed blocks of 19th century buildings and perhaps the first state house. Designed by Marcus Reynolds, he based the design on the Flemish Gothic style of Cloth Hall in Ypres, Belgium. Ironically while this building was going up, the original building was bombed to pieces by the Germans in World War I.

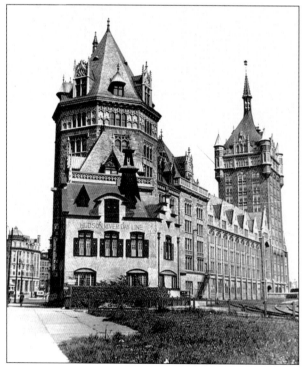

Seen is this photograph are the Hudson River Day Line ticket office and the Albany Evening Journal building, both landmarks that still exist today. The ticket office for the Hudson River day liners still stands but served as a restaurant in recent times. The Albany Evening Journal building was erected and matched to the D&H building by Republican leader and publisher Billy Barnes and now is part of the SUNY administration.

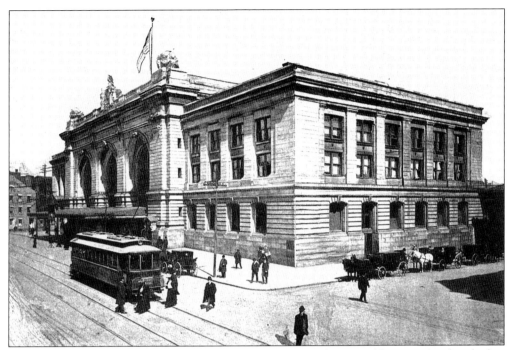

Albany's Union Depot railroad station was built in 1900 and was used by several railroads that served the population. It was the center of the city for many years, until the trains stopped running in the 1950s. The building was slated for demolition but saved by an enlightened bank president and now serves as their main offices.

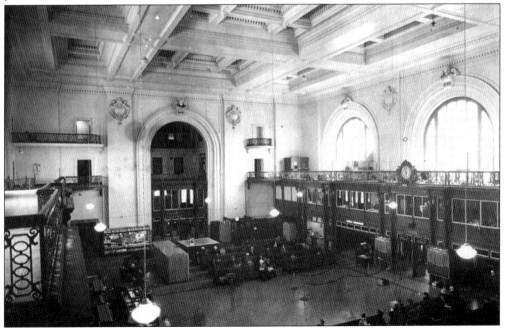

The interior of Union Depot is seen here as it appeared when trains were running gave riders a feeling of opulence and comfort. Now the building is used for offices, but the interior has been painstakingly restored.

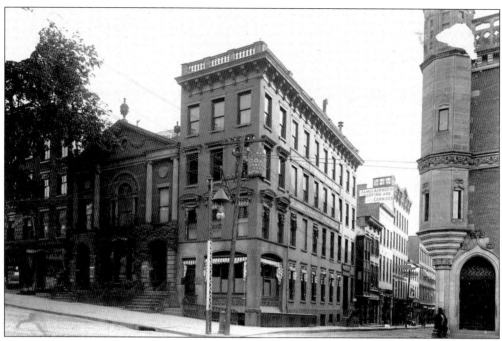

The northwest corner at James and State Streets showing the Albany Coal Company, and just to the west of it, the State Bank building, seen here in this 1890s photograph, reflect the times. Architect Philip Hooker designed the bank, and the facade still exists in the skyscraper that now occupies the entire block.

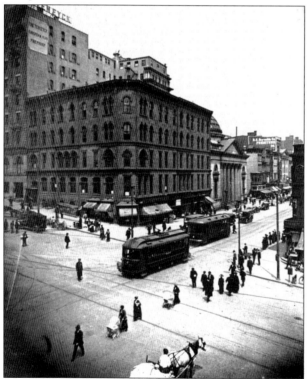

A bygone view of the northwest corner of State and North Pearl Streets is seen here, showing Tweedle Hall and trolleys. The concert hall was erected in 1860 but burned in 1883 and was replaced by this newer building. The hall was then replaced by the nearby Ten Eyck Hotel in 1915.

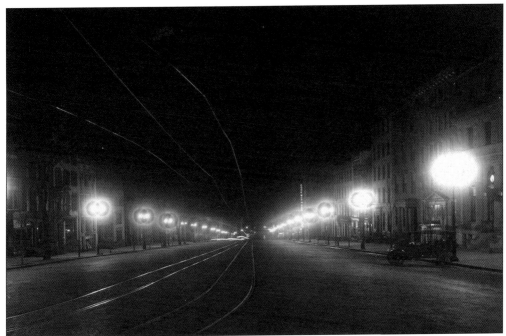

This is a night view looking down State Street from the capitol area (Eagle Street) in 1915, showing the placement of new street lamps. Notice the "ghost" car on the right and the overhead trolley wires with the sign that tells trolley cars to stop there. Keeler's Restaurant sign can be seen at the bottom and the utility company's "Cook with Gas" neon sign advertises.

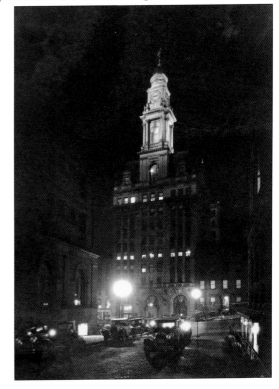

Here one can see a wash of lights on the Albany Savings Bank at night from Chapel Street looking to State Street on April 22, 1929. The bank building was built in two sections. The first section on the left was built in 1902. The second portion built in 1925. As one of the first skyscrapers, the dome was illuminated for years.

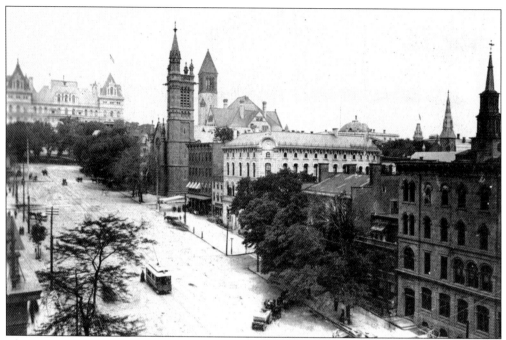

This image shows an impressive view up State Street showing the capitol building, Albany City Hall, St. Peter's Church, and the Albany Savings Bank on the north side of State Street. Notice the trolley going up the hill. This used to be the scene of the public market in the mid-19th century.

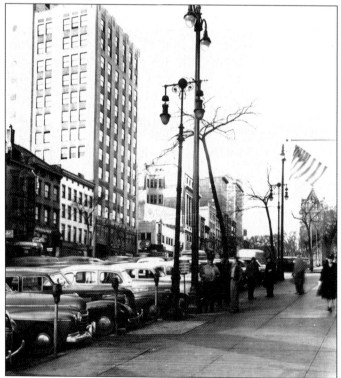

This view shows a busy day view up State Street on December 13, 1946. Notice that many of the residences on this side of State are being reused for commercial businesses. Today they have been replaced and are now part of skyscraper row. The tall building, the Standard Commercial building, was Albany's first skyscraper, built in 1928.

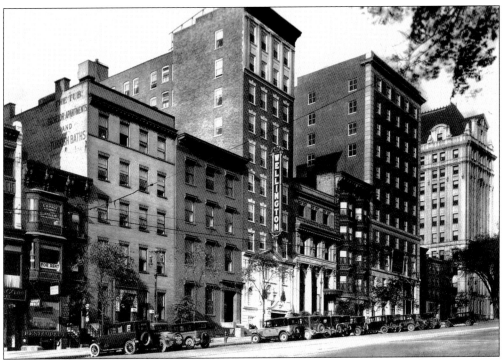

Wellington Row between Lodge and Eagle Streets is one of Albany's endangered blocks and was in danger of being demolished recently. The Wellington Hotel, and further up the block, the DeWitt Clinton Hotel, were two popular hotels for politicians. To the left of Wellington was the "Tub," a place for bachelor apartments and Turkish baths.

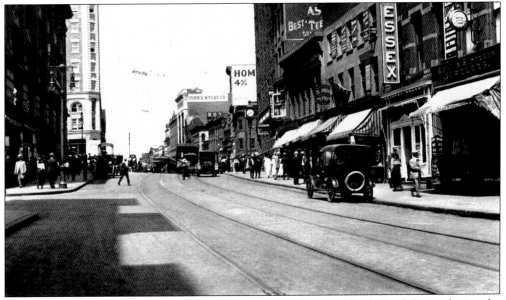

South Pearl Street just south of State Street was just as busy as North Pearl Street during the early part of the 20th century, even though the street was not created until the 19th century. Parts of the Ten Eyck Hotel can be seen on the left at the corner of State Street in this 1920s photograph.

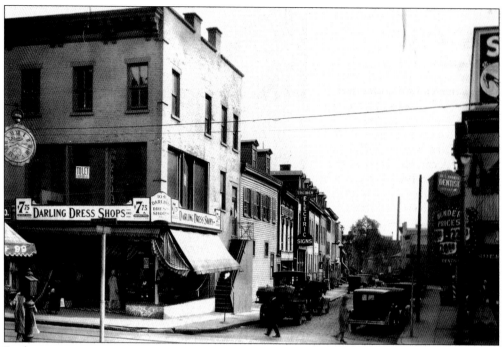

Darling's Dress Shop at 104 South Pearl Street at 8:15 p.m. is just one example of the many retail and commercial outlets that lined this historic street. Notice that their daily price for a fine dress is only $7.75 in this 1920–1930s photograph.

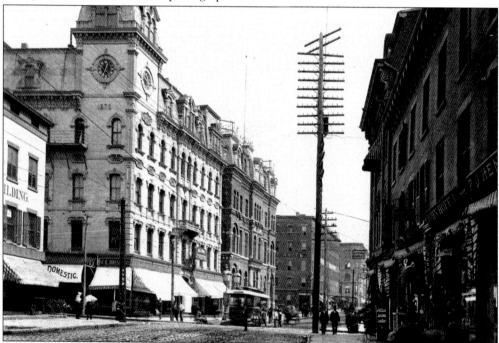

South Pearl Street and Martin's Hall, or Opera House, on the corner of Beaver Street, was an impressive site. The hall burned in 1886. The Globe Hotel can be seen on the southwest corner of State Street, and across the street, Tweedle Hall can be seen in this c. 1910 photograph.

This view of North Pearl Street in the 1920–1930s reflects the change from a 17th century residential street of small, one-and-a-half-story homes to tall commercial structures over the span of 300 years. This view, looking south towards State Street, shows the Home and City Savings Bank built in 1927. The State Bank can also been on the corner, built in 1927–1928, which incorporated the facade of its original 1805 bank building on State Street into it.

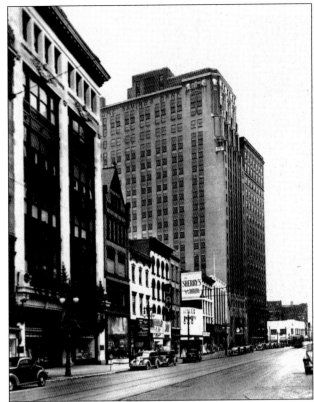

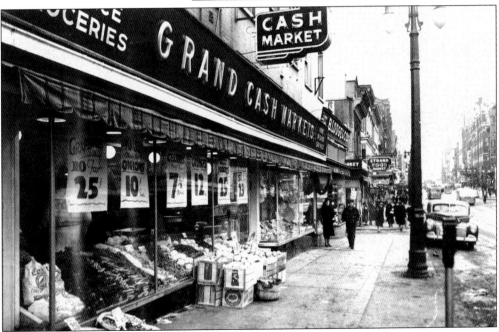

The area around North Pearl Street near Columbia Street was a busy commercial corner. There was a time when you could buy your groceries downtown and in this 1930s photograph, onions were 10¢ for a 10-pound sack and 10 grapefruits cost 25¢.

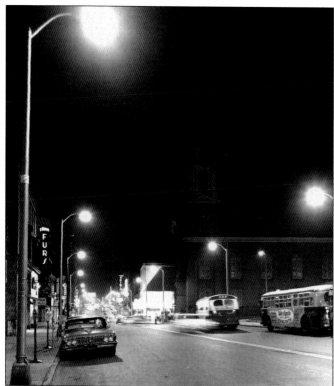

Seen here is a night view of North Pearl Street, just south of Clinton, on August 14, 1961, when this part of downtown was active. The Dutch Reformed Church, the oldest in the city, can be seen in the foreground on the right.

The intersection of Eagle and State Streets on the south side was residential in nature during the first quarter of the 20th century. The telephone building can be seen on the far right and several residences to the left of it. The trolley tracks come down Capitol Hill and turn down to State Street. Capitol Park can be seen to the right.

To show a contrast, here is a night view of the same area as the previous photograph but taken on August 14, 1961. City hall can be seen on the left, while the mansion on the southeast corner of Eagle Street was replaced later by the Dewitt Clinton Hotel.

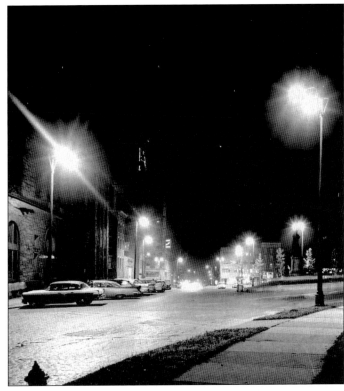

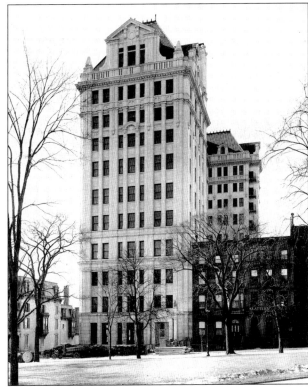

The Telephone Building was erected in 1914–1915 and rises 221 feet above the surroundings. Albany had one of the first phone systems in America. In 1877, one year after Alexander Graham Bell introduced it, a line ran from the Atlantic and Pacific Telegraph building at 444 Broadway to the residence of Charles Sewell at Bath in the Hudson. In 1916, there were 20,190 telephones.

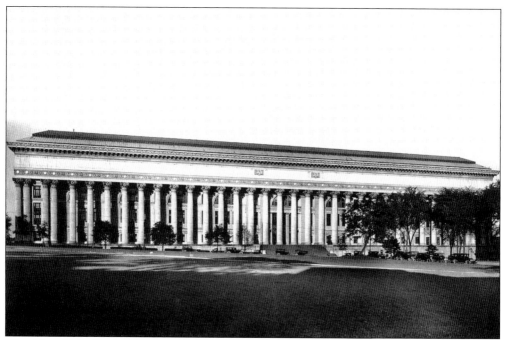

The New York State Education Building was built in 1912 and spans an entire block of Washington Avenue. It covers 21.2 acres, and its 36 massive columns are believed to be the largest in the country, each 60 feet high. The New York State Library and New York State Museum relocated there (both now are part of the Empire State Mall).

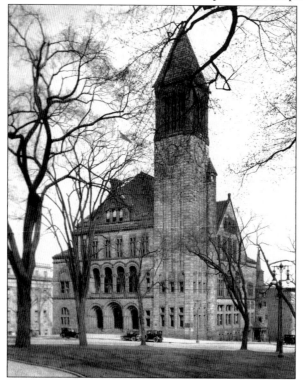

One of the most beautiful buildings in Albany is city hall, shown here in the 1920s. Designed by H. H. Richardson, it replaced the earlier one that had burned in 1880. This new one opened in 1881 and still serves as city hall. Criminals once were hanged in the backyard.

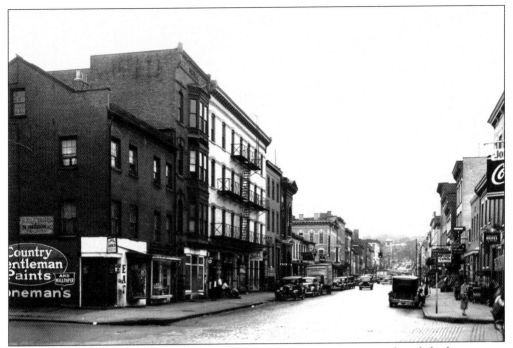

The intersection of Madison Avenue and Dallius Street seen here was demolished years ago. When this 1920s photograph was taken, the corner building was 150 years old. The building with the fire escape is the old Farmers Hotel.

A view of Madison Avenue on the south side near Allen Street, along with the Madison Diner, is indicative of this part of Albany, residential mixed with commercial. Many small diners existed throughout the city but only a handful remain today. The Madison Diner is one diner that did not survive.

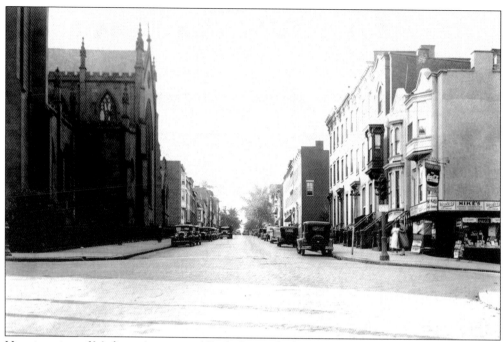

Here is a view of Madison Avenue and Eagle Street, looking west, that will never be seen again. Note the Cathedral of Immaculate Conception on the left. This is the only building remaining in this view as the area was replaced by the Empire State Mall in the 1960s.

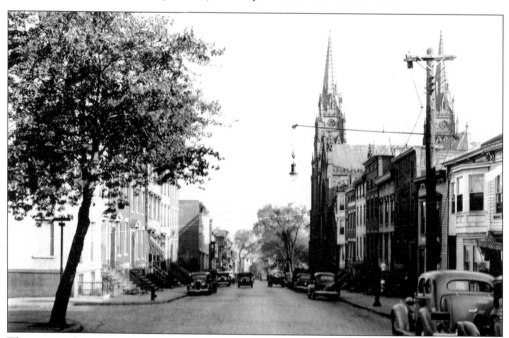

This is another view of Madison Avenue looking east to the corner of Eagle Street and is the opposite of the previous photograph. This stretch of territory to State Street north, some 98 acres, was leveled between 1965 and 1978 for $1.7 billion to make way for the Empire State Mall.

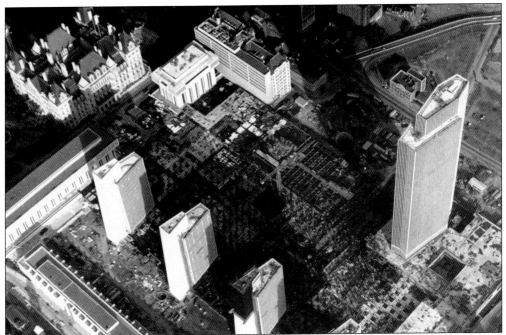

The Governor Nelson A. Rockefeller Empire State Plaza (commonly known as simply the Empire State Plaza and less formally as the South Mall) was completed in 1978 for $1.7 billion. Today over 13,000 state workers commute here daily. The plaza consists of several marble and steel buildings, seated on a six-story marble platform along the Hudson River. During the summer, waterfalls tumble on the eastern facade, giving it a pre-Columbian appearance.

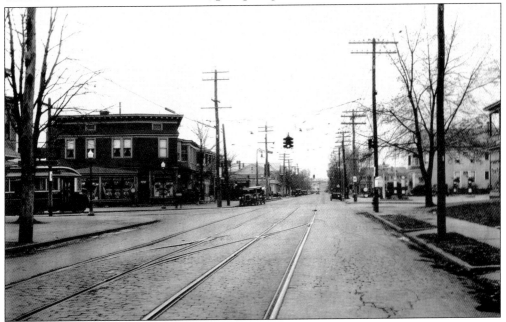

This is a solitary view of Delaware Avenue and Second Avenue in the southern section of the city. Delaware Avenue, really a turnpike in earlier days, led to Delmar. This view is showing trolley tracks and a trolley in this 1920s photograph.

Clinton Avenue was the northern border of early Albany for many years, and this view of lower Clinton to North Pearl Street, north side, reveals its neighborhood feeling. The end buildings were demolished for the erection of the Palace Theatre in 1931 during the Depression. Originally an RKO movie house presenting vaudeville acts between feature films, the Palace Theatre boasts an ornate Austrian Baroque design and today is one of the most beautiful theaters in the Capital District. The Pruyn Library is at the end of the street (now demolished).

The south side of lower Clinton Avenue to North Pearl Street shows the same residential character as the previous photograph. The Third Presbyterian Church can be seen on the bottom right, and it ended up a theater showing silent movies. Most of the buildings seen here have been razed.

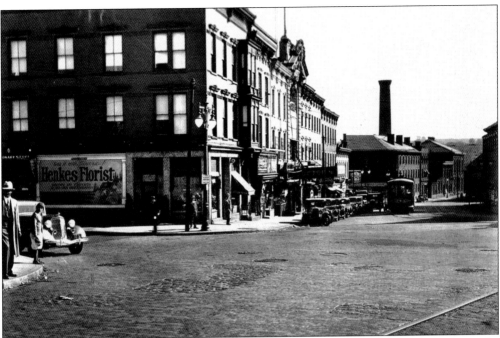

This view of Clinton Street between North Pearl Street and Broadway, as it appeared in the 1920s, is so dramatic because the entire block was razed and now a sole, nondescript federal government building occupies the site. The Albany Pump Station can be seen at the end (smokestack) of the block and is all that remains today, although it serves now as a microbrewery.

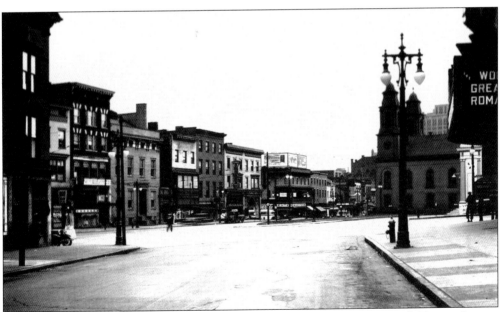

A view to the south from North Pearl Street looking to Clinton Avenue and Clinton Square, which no longer exists, finishes this look at a section of Albany that has been drastically altered. The Palace Theatre marquee can be seen on the right. The Dutch church further down Pearl Street can be seen, but all the buildings to the left have been razed in this 1930s photograph.

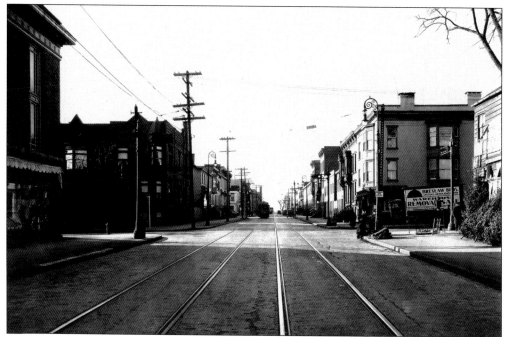

A view of Lark Street looking south from Hudson Avenue towards Madison Avenue reveals one of the few streets that remain relatively unchanged over the years. A trolley is headed towards the view. Lark Street is Albany's version of Boston's Charles Street with small specialty shops and eateries. An annual Lark Fest draws thousands.

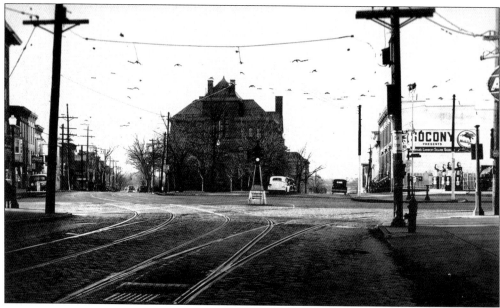

Here is a view of Lark Street as it intersects with Madison Avenue and Delaware Avenue, in the center. Dana Park is a two-acre park named in honor of New York State mineralogist Dwight Dana. The Dana Fountain was erected by the Dana Society on April 27, 1903. The Dana Natural History Society of Albany was organized November 21, 1868, and was one of the few organizations composed of solely of women.

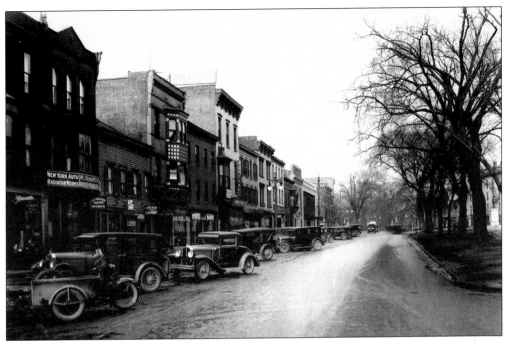

This section of Albany is where two turnpikes begin to spread west, as this 1920s view shows. Here the view is of the south side of Washington Avenue where it intersects with Central Avenue and Lark Street. A small park is on the right.

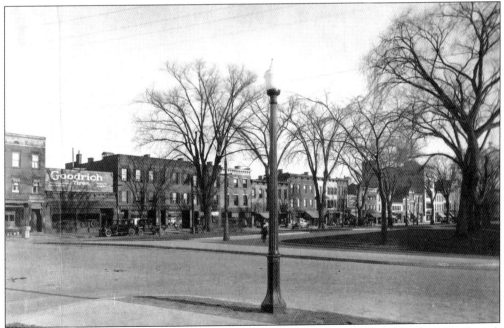

Townsend Park separates Central Avenue (Albany-Schenectady Turnpike), Northern Boulevard, and Washington Avenue. The four-acre park was originally designed as a tribute to George Washington but instead was dedicated to one of Albany's mayors, John Townsend, mayor from 1829 to 1831. The park was improved in 1916.

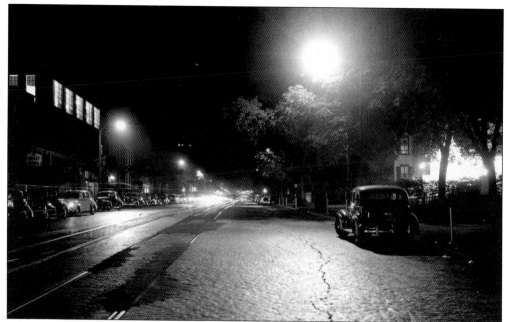

This is a night view of somewhere on Washington Avenue on October 2, 1947, showing the Belgium block street, which is now replaced with asphalt. The trolley tracks are also covered with asphalt.

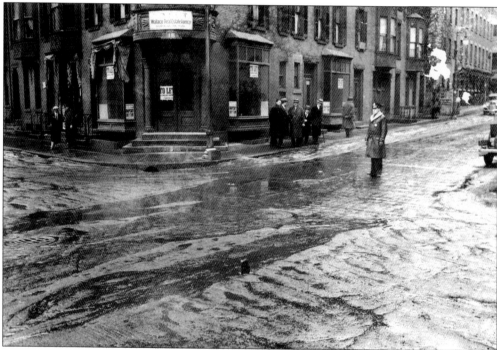

An accident scene during the 1920s is seen here, at an unknown intersection (maybe Clinton Avenue) showing a policeman guarding the spot. The distance from the spot where the victim, named Ryan, was struck to the spot where automobile stopped is about 24 feet 10 inches. This probably means the driver was speeding.

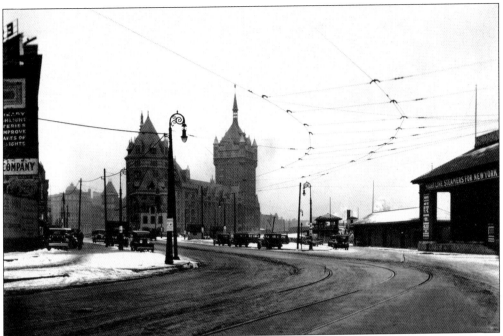

In this 1920s-era photograph, the night steamers office and storage on the right can be seen in this view looking north along Broadway at Steamboat Square. Fares were $2 and $5 with staterooms at $1.50. A sloop mast is also visible in the background. Further is the train switch house, and both the D&H and Albany Evening Journal building can be seen. The Hudson River is to the right, but today this area of the river is filled in and part of the Interstate 787 road system.

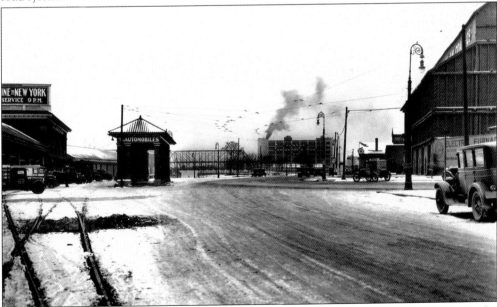

Here is a c. 1915 view of the same area looking south and showing the Parker Dunn bridge in the background, the Albany Hardware and Iron Company store (large building), and the steamboat launch on the left. The large building to the right is a coal storage shed.

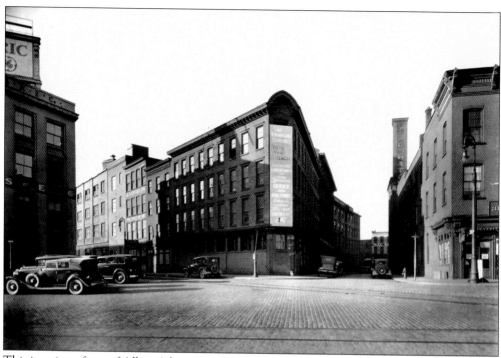

This is a view of one of Albany's businesses, The Embossing Company at the corner of Broadway and Pruyn Street, around 1935–1940. This area has been altered by the construction of Interstate 787 and has no semblance of this view today.

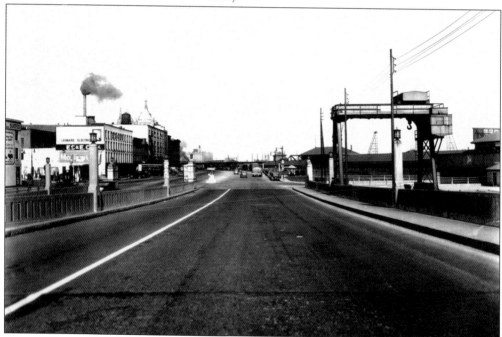

This 1930s view is the on-ramp of the Dunn Memorial Bridge from Broadway looking north. Steamboat Square is to the right, and the large building in the background is the Central Terminal Warehouse that is sitting in the former water basin of the terminus of the Erie Canal.

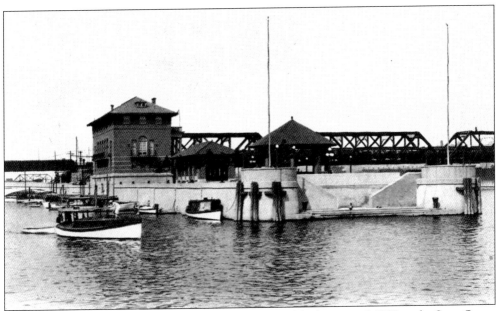

This is a former view of the Albany Yacht Club basin and docks, around 1925, at the State Street Pier. The railroad bridge is in the background and to the right, but not visible, is the D&H building. This area is filled in and buried by Interstate 787.

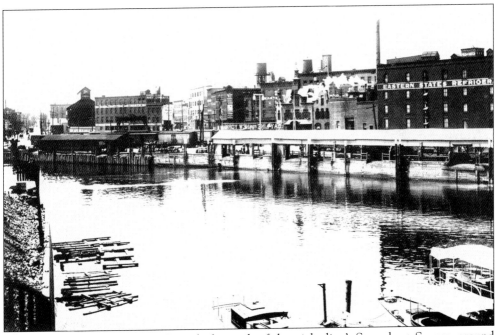

This is the Hudson River Day Line dock, north of the night line's Steamboat Square, around 1900 and taken from the Yacht Club pier. The ticket office building, which still exists today, can be seen on Broadway. The area to the right was razed to make way for the D&H building and the Albany Evening Journal building in 1915.

A trolley traveling west on Madison Avenue near Manning Boulevard, around 1918, reveals this residential neighborhood that could almost be considered a suburb during this time. An extensive trolley system took passengers throughout the Capital District and eventually became the United Traction Company. With today's gas prices, trolleys would be welcomed back with open arms.

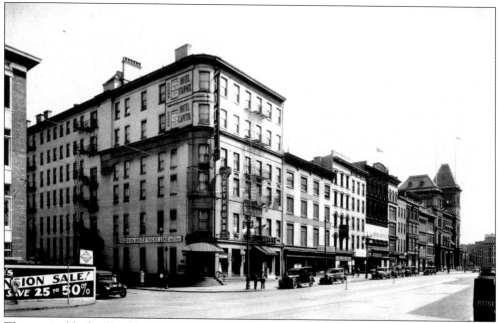

This entire block of buildings was torn down as far as the government building to make room for the new post office building built in 1933. This view of Broadway from Maiden Lane looking south shows the old Stanwix Hotel as the tall building in the center.

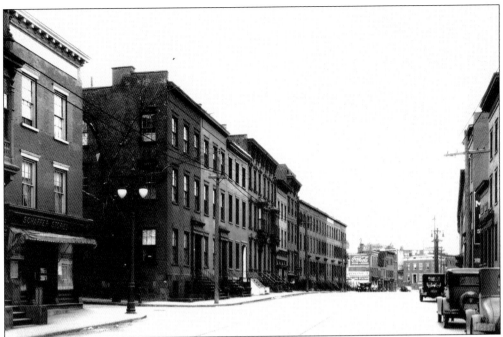

This is a residential view of Broadway above Wilson Street, near Livingston Avenue, and just north of Clinton Avenue, about 1920. The first building on the left was the home of John Ten Eyck in 1890. The Ten Eycks were an old established Albany family. Many of these buildings have been razed.

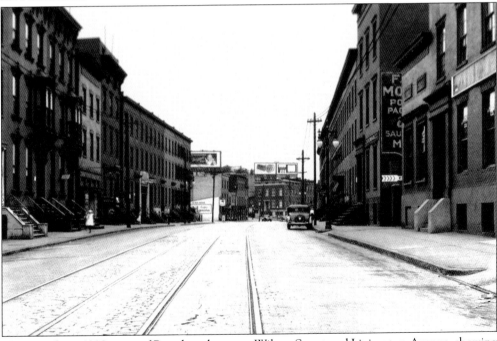

Here is a closer 1920s view of Broadway between Wilson Street and Livingston Avenue, showing both sides of Broadway and trolley tracks. Broadway was the main road to points north such as Menands, Watervliet, and Troy, until the large interchanges were built in the 1960s.

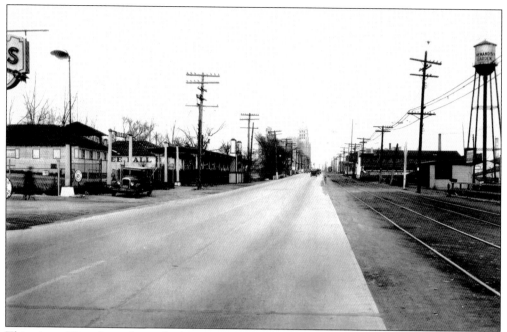

This view of Broadway shows the long stretch as it approaches Menands, a suburb to the north. This is the route to Hawkins Stadium, where the Albany Senators baseball club played for many years. The gas station on the left was advertising gas for 12¢ a gallon. The large building in the background is the Montgomery Ward warehouse. Notice the trolley on the right.

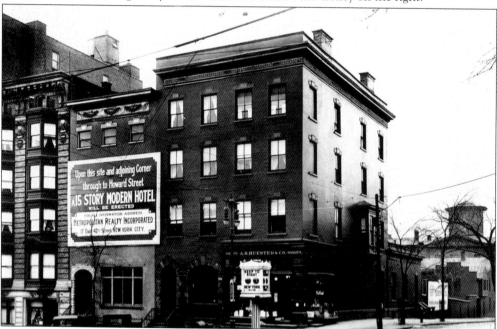

The southeast corner of Lodge and State Streets was a residential neighborhood and then transformed to commercial when these homes were torn down to make way for the Dewitt Clinton hotel and those further, including the Wellington Hotel. The Albany Hospital (former jail) can be seen on the right.

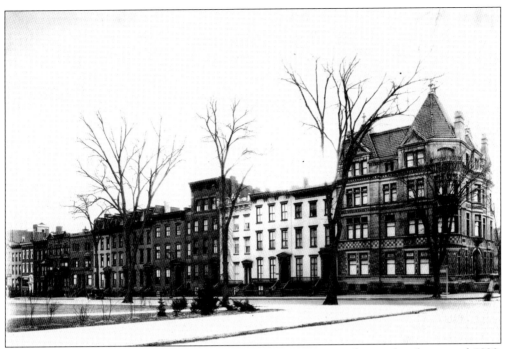

Here is a former view of State Street east from Swan Street, on the south side, around 1920, before it disappeared. This entire row has been replaced by the New York State office complex and Capitol Park is to the left.

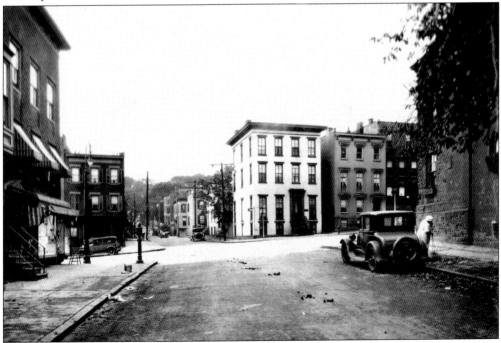

This is another ghost view of Madison Avenue looking at the south side, and corner of Philip Street around 1920. Much of this area has been altered due to the construction of the Empire State Mall.

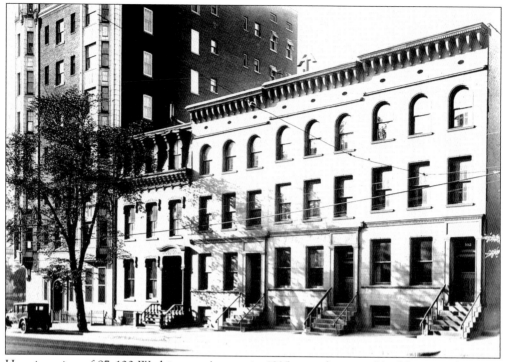

Here is a view of 97–100 Washington Avenue in 1925 near the capitol building, on the south side. This block and the Fort Frederick Apartment building on the left were removed to make way for the Alfred E. Smith State Office Building in 1929.

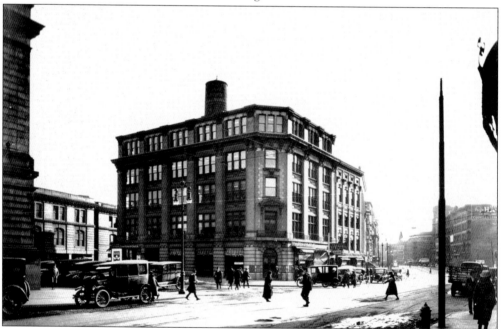

Seen here is another view of the old Stanwix Hotel and the earlier Union Depot in the back of the hotel on Broadway, around 1915. While Union Station is still there, the rest of these buildings seen here have been replaced by large office buildings.

This eerie night view is looking up Washington Avenue from Northern Boulevard around the 1930s. The western part of Albany was not very settled much further west than this and extended into the Albany Pine Barrens, a large expanse of unique plant and animal communities and sand dunes.

This is a winter view down New Scotland Avenue on Thursday evening, January 24, 1929, and shows a well-lit boulevard by new General Electric (GE) streetlights. People were waking up to the beginning of the Great Depression.

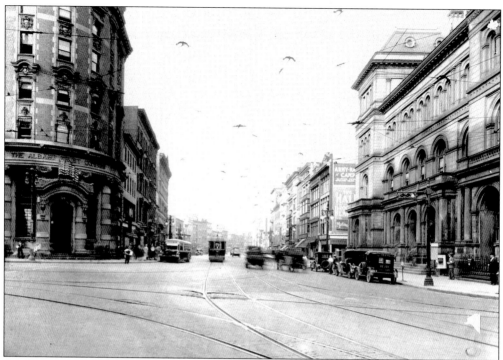

See here is a day view looking north on Broadway from State Street on October 5, 1926, the day new street lamps were installed. This photograph and the next were taken by a GE employee who was testing the installation of the new streetlights.

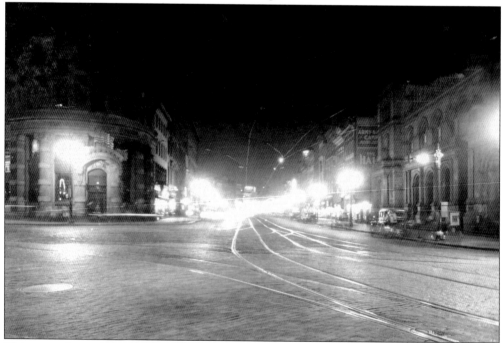

This is an identical view looking north on Broadway taken the same night on October 5, 1925, to demonstrate the new GE street lighting recently installed.

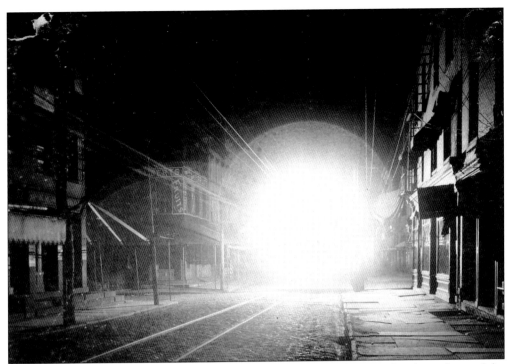

Here is an interesting view of Broadway at night in the 1890s, showing the glare of one of the first street lamps. Notice there was no one walking the streets.

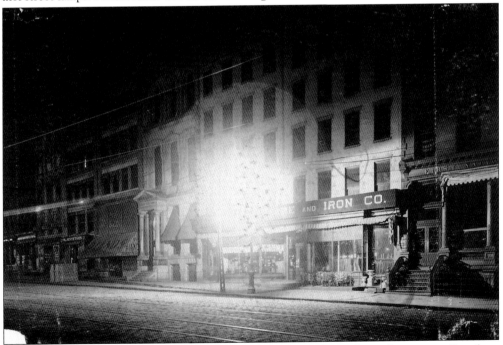

Another night shot showing the glare of a street lamp on lower State Street near Broadway in the 1890s reveals that GE was experimenting with public lighting in front of the Albany Hardware and Iron Company store.

This is a view of Swan Street south of Washington Avenue before the Alfred E. Smith State Office Building was built in 1930. This 1920s view shows several homes and the Fort Frederick Apartment building before it was picked up and moved to the other side of State Street where it still stands.

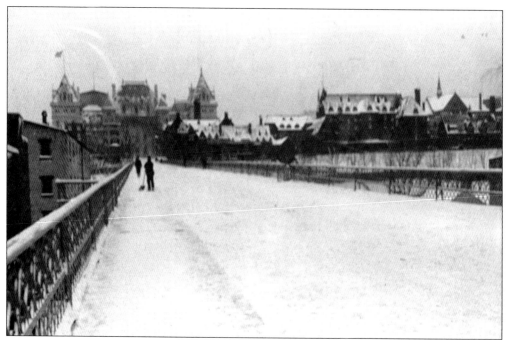

The Hawk Street Viaduct around 1920 took the working class population that lived in the northern section of the city to downtown. The viaduct ended on Columbia Street and went over to the capitol building but was dismantled in 1970 due to safety reasons.

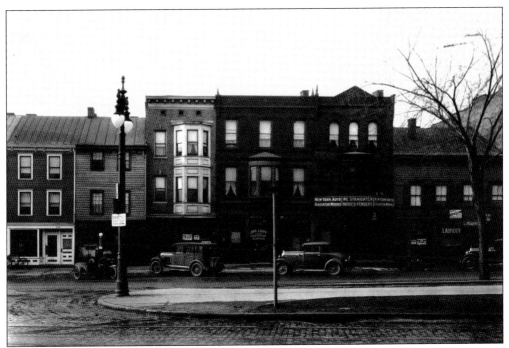

This is a view of Washington Avenue where it intersects with Central Avenue above Lark Street, looking south, around the 1920s, and shows a row of buildings that still stands today and is in use. Townsend Park, seen in the foreground, separates the two streets.

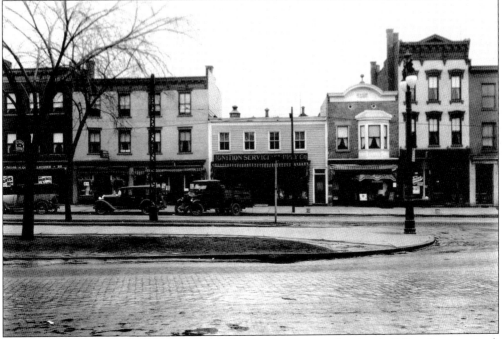

This photograph is the companion view of the previous image, showing buildings between Lark Street and Northern Boulevard on Central Avenue. The east end of Townsend Park is also visible here.

James Street, seen here, looking north from State Street to Maiden Lane during the 1930s, was a small but active street. Kresge's Department Store, the Morris Lunch room, and other commercial vendors occupied this small street which today is vacant.

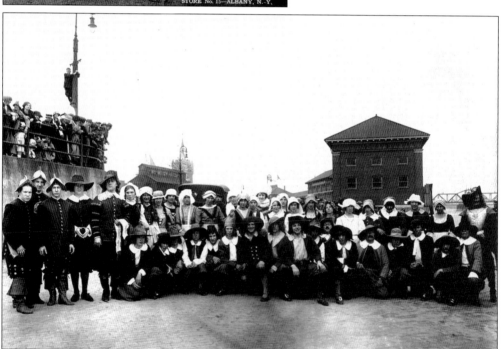

The Albany tercentenary group is shown here celebrating at the dock of the Albany Yacht Club in 1924. Albany (Fort Orange) was settled in 1624, though a Fort Nassau had been built on the nearby Castle Island in 1614.

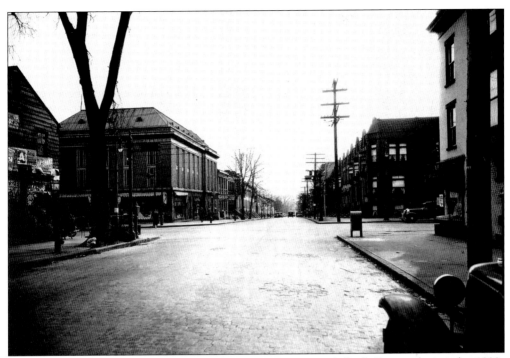

A view looking east on State Street, where it intersects with Lark Street, during the 1920s shows a part of Albany that has not changed much. It is one of the few intersections that remain untouched.

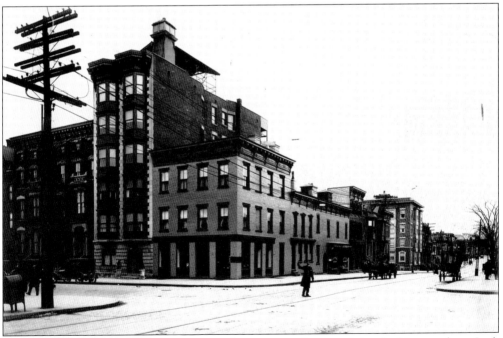

Here is a view of the same intersection as the previous photograph but looking south on Lark Street where it intersects with State Street. Notice the policeman directing traffic having to deal with horse and wagons, trolleys, and automobiles.

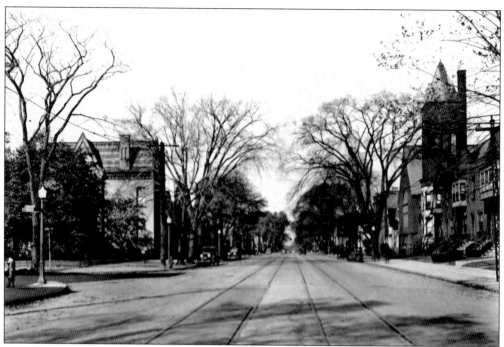

Clinton Avenue was the northern limit line of Albany when it was incorporated in 1686. It was the longest and skinniest city in the world (1 mile wide and 16 miles long). This is a view of Clinton Avenue and Robin Street looking west during the late 1920s, not far from Tivoli Lakes.

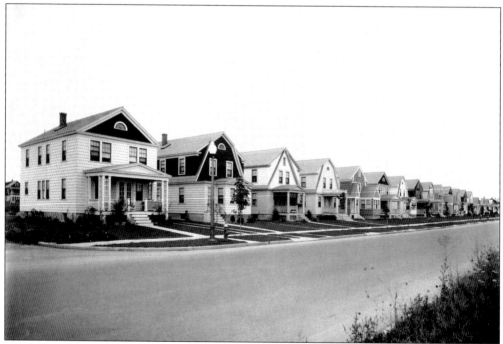

Here is a view of some of the first suburban tracts to go up in Albany as the city moved off the flood plain and up the hill. This row of houses was built along Academy Road in 1920.

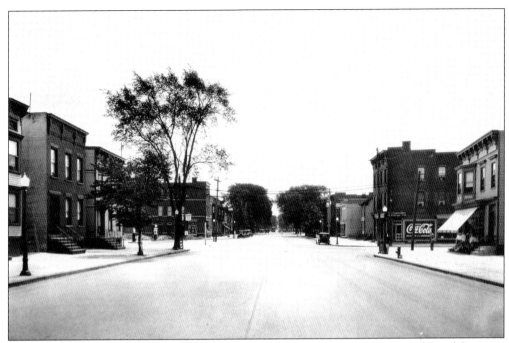

Here is another residential view of Clinton Avenue looking east at the corner of Quail Street in 1930. Notice the trolley coming up from downtown.

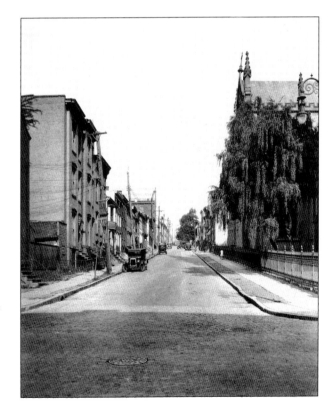

Jefferson Street does not exist anymore, as these buildings, except for the church, have been torn down for the New York State Education Building and parking. This view of Jefferson Street as it meets Eagle Street was taken around 1915. The Cathedral of Immaculate Conception is to the right as well as Madison Avenue.

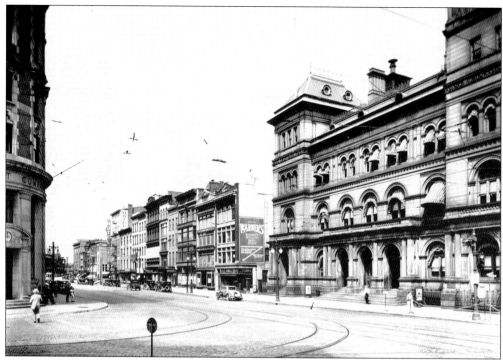

Here one can see a 1930 view of Broadway to Maiden Lane showing a clearer view of the buildings that were demolished to make way for the new federal post office of 1933.

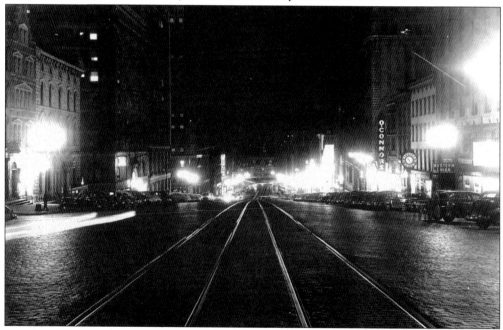

Another night view looking down State Street from Eagle Street shows a busy night scene on November 6, 1946. It was the night that the Senate and House of Representatives elections in the United States both gave majorities to the Republicans. It was also the date that flying nun Sally Field was born.

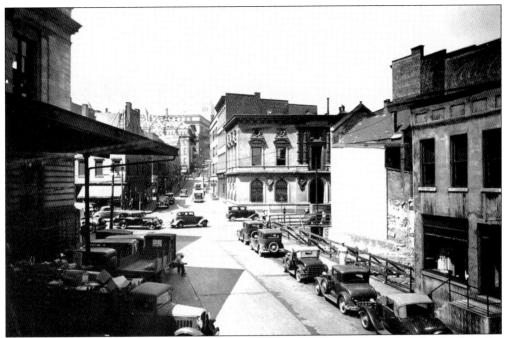

Columbia Street is seen here during the 1920s–1930s when trucks were loading freight from the Union Depot and offices at the United Traction Office building across the street were active. Stores and restaurants lined Broadway and a short walk up to North Pearl Street to the Kenmore Hotel is where notorious gangster Legs Diamond hung out.

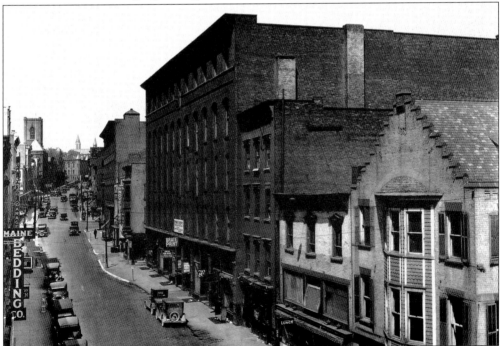

This is a view that no longer exists where Clinton Avenue goes to North Pearl Street in 1907–1910. Memorial Hospital and the steeple of the Fourth Reformed Church can be seen here.

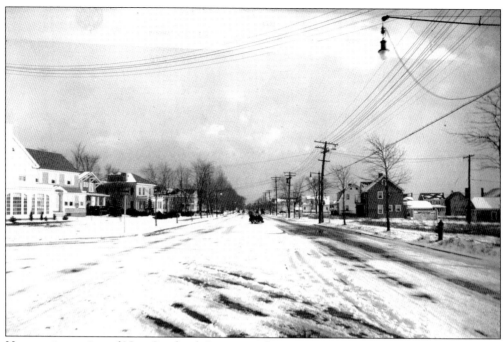

Here a winter view of New Scotland Avenue on January 23, 1929, was considered "out in the sticks" and rural.

This close-up of a few homes and street lamp on New Scotland Avenue on January 23, 1929, shows a suburban nature of this residential development.

Four

LANDMARKS

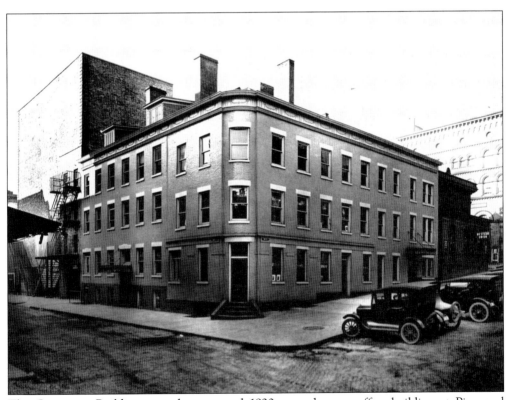

The Commons Building, seen here around 1920, served as an office building at Pine and Chapel Streets, until it burned. Many landmark buildings exist in Albany today as well as in former times.

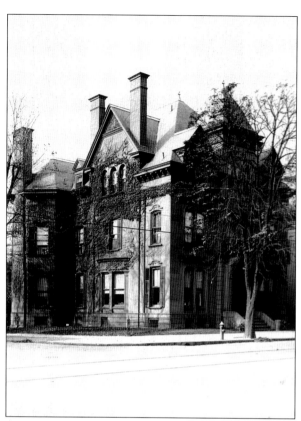

The mansion of William Minot Whitney, founder of the department store of his name on North Pearl Street, was located at 161 Washington Avenue. It was raised to build the Harmanus Bleeker Library around 1924.

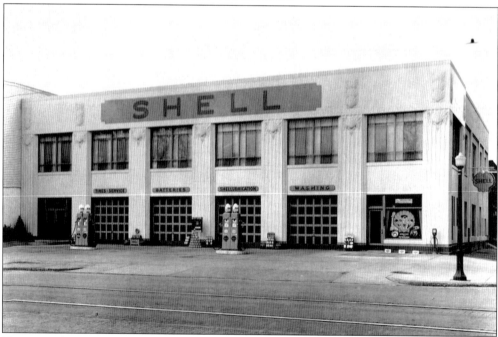

Here is a Shell station on West Lawrence and Madison Avenue that served gas, cleaned your windshield, and all for a few cents a gallon during the 1930s.

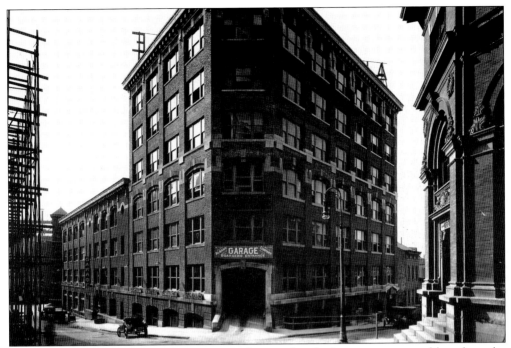

The Albany Garage as seen here is a good example of what garages were like when the automobile was becoming king of the road. Automobile garages had more style before the days of bottom-line profit decisions. This architectural gem was only recently torn down.

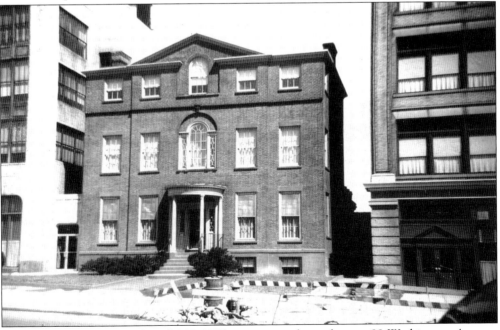

The Gov. Daniel D. Tompkins (1807–1817) mansion is shown here at 99 Washington Avenue. Tompkins was considered an entrepreneur, jurist, and was elected to Congress, became the fifth governor of New York, and served as the sixth vice president of the United States (March 4, 1817–March 4, 1825) under Pres. James Monroe.

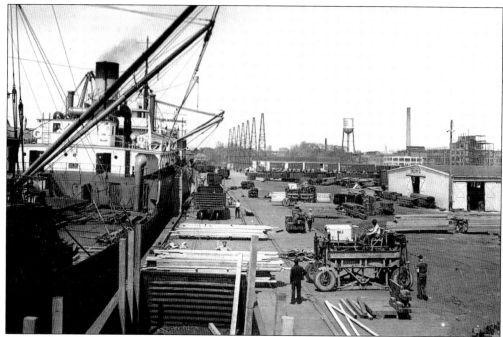

Located on Castle Island (now attached to the mainland) where the Dutch built Fort Nassau, the Port of Albany was dedicated on June 6 and 7, 1932. The Albany Port District Commission (also known as the Commission) was established in 1925. This photograph was taken of the Port of Albany on February 5, 1932.

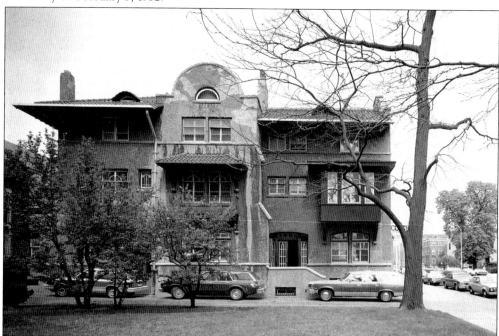

This beautiful arts and crafts building located at 116 Washington Avenue was torn down by its owner the Fort Orange Club in recent years for more parking space. Originally built in the 19th century, there was opposition by preservationists to save the building but they lost.

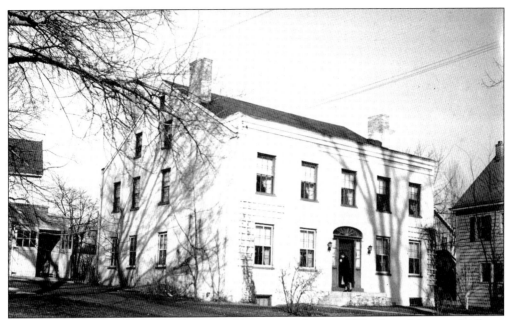

The Jesse Buel Farm House at 637 Western Avenue was built in 1821 when this part of Albany was wilderness. Buel was an agricultural reformer and had developed many varieties of apples on this farm, which at the time was located in the Albany Pine Barrens. His accomplishments include publishing the Troy *Budget* in 1797, the Poughkeepsie *Guardian* in 1801, and the *Cultivator* in 1834. This photograph was taken April 9, 1934, and remains today a residence although surrounded by suburbia.

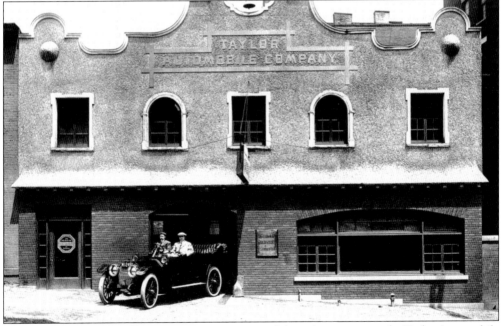

At a time when horse and buggies were competing with horseless carriages, the Taylor Automobile Company at 33 Orange Street, between Pearl Street and Broadway, was one of the first garages in Albany as seen here in 1907.

The Hun House at 149 Washington Avenue was built about 1810 and believed to have been designed by Albany architect Philip Hooker.

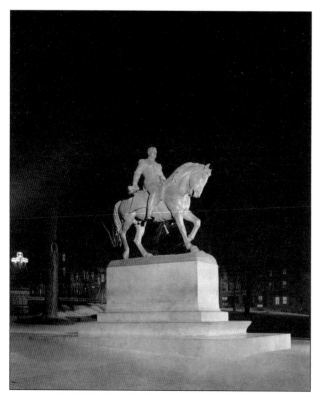

This is the Gen. Philip Henry Sheridan statue in front of the New York State Capitol building on Washington Street facing Eagle Street. Sheridan (1831–1888) was one of the most celebrated heroes of the Civil War. The statue was dedicated in 1916, five years after the capitol building burned.

Nipper the RCA dog, at Broadway and Loudonville Road, has been an Albany landmark for years. The real Nipper lived during the 19th century. This four-ton Nipper was erected in 1954 on this RCA Distributor building. It now is owned by a moving and storage business that advertises Nipper as "the watchdog of your possessions."

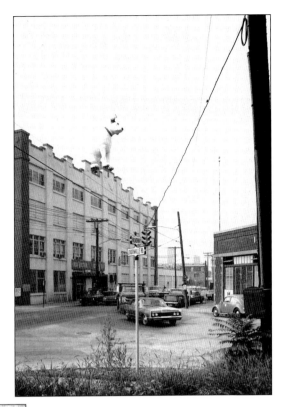

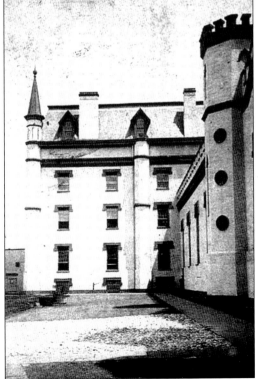

The Albany Penitentiary, formerly located where the Stratton Veterans Affairs Hospital is today near New Scotland Avenue, was opened in 1846. It was used during the Civil War to house POWs. Gen. Amos Pilsbury was the first superintendent (a former chief of police in New York City) until 1873. His son Capt. Louis Pilsbury took over as superintendent when his father retired.

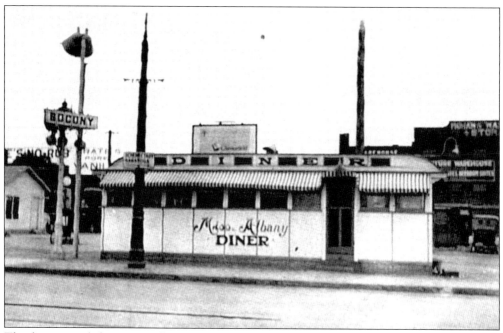

The location of this Miss Albany Diner is unknown, but it may have been on Broadway. According to diner aficionado Mike Engle, there were seven Miss Albany Diners in the city. Popular in the 1920s, the surviving Miss Albany Diner (built 1941) at 893 Broadway still serves a great breakfast and lunch for anyone wanting a great dining experience in a historic setting.

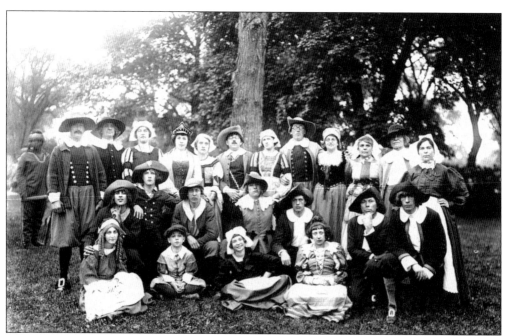

A group of Albanians are dressed up here in native Dutch settler costumes at Washington Park during the city's tercentenary pageant and celebration, 1624–1924. In earlier years, Albany heavily celebrated its history.

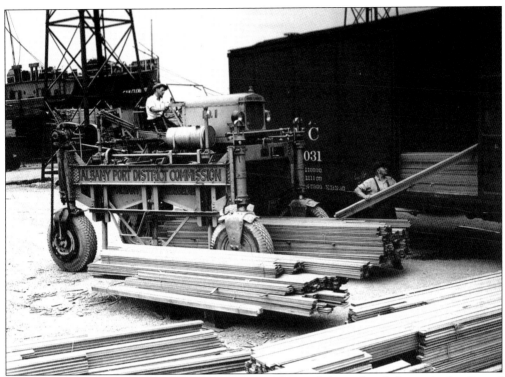

These photographs were taken when the port was being dedicated and shows the loading of brick and lumber on a boxcar in 1932.

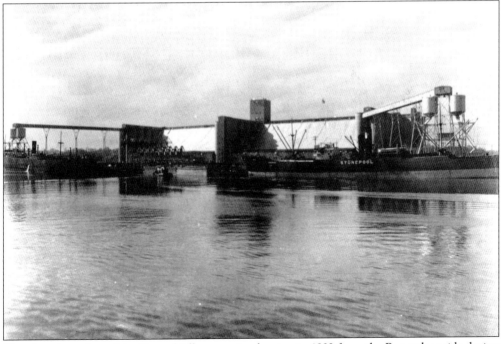

Here is a river view of the Port of Albany grain elevator in 1932 from the Rensselaer side during the dedication of the port.

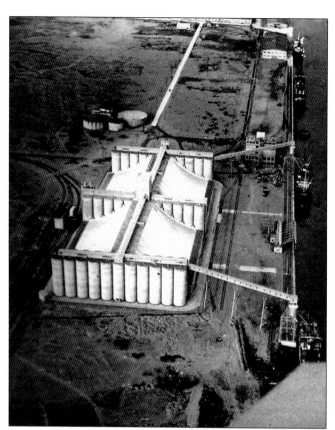

Here is an aerial view of the new grain elevator built at the Port of Albany in 1932.

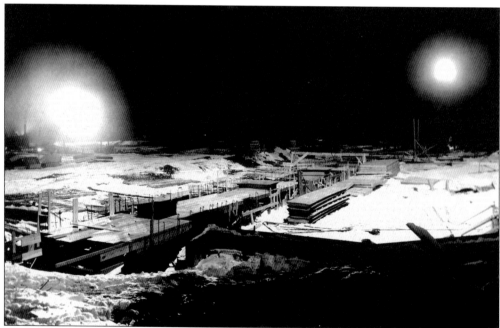

This night view of the construction of the grain elevator at the port on February 5, 1932, was taken to promote the site being lit by new GE lights.

The State Normal School on Willett Street in Washington Park was built in 1885, after being on upper State Street near Lodge and Lark Streets, and then to this new building. It burned and was replaced by the State Teachers College on Western Avenue, now the State University of New York at Albany.

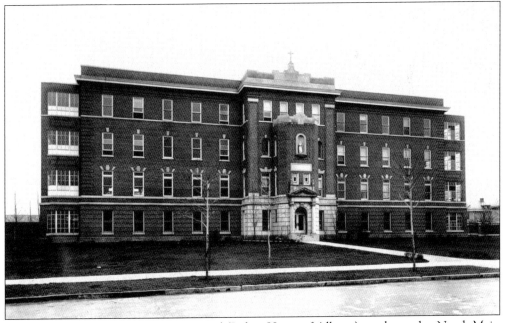

The (Anthony) Brady Maternity Hospital (Infant Home of Albany) was located at North Main Street. Many people were born in this former hospital.

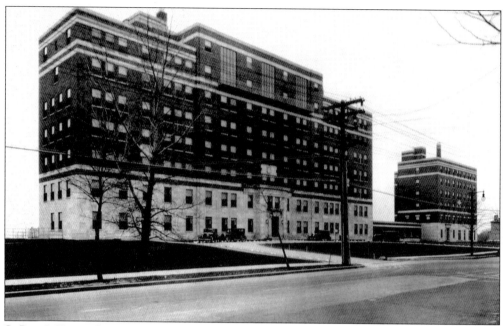

St Peter's Hospital on New Scotland Avenue was started by the Sisters of Mercy in 1869. This view around 1930 shows the current location, but the hospital has expanded over the years.

Fort Frederick Apartments, 248 State Street, is on the corner of Swan and State Streets. This building was literally picked up whole and moved down one block from the corner of South Swan Street and Washington Avenue to here.

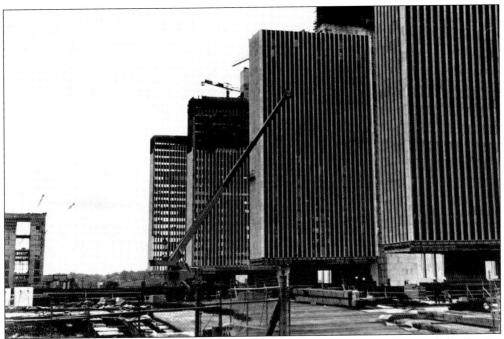

Here one can see the rise of Agency Buildings (1–4) and the Corning Tower of the Empire State Plaza going up between 1965 and 1978 at a cost of $1.7 billion. Many neighborhoods were displaced by this monster project of then Gov. Nelson Rockefeller and the population has dwindled ever since.

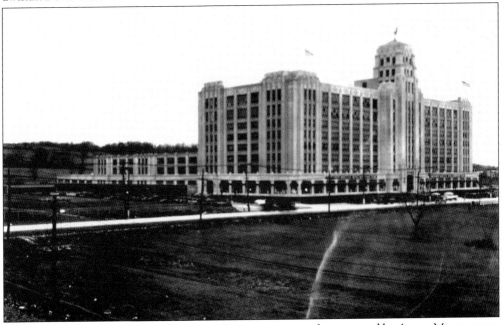

Montgomery Ward, the former American department store chain started by Aaron Montgomery Ward, was the world's first mail-order business, beginning in 1872. By 2001, the company closed all its stores. This view is the Montgomery Ward warehouse and offices on Broadway in nearby Menands. It closed in the 1980s, only to be rehabbed in recent years as an office building.

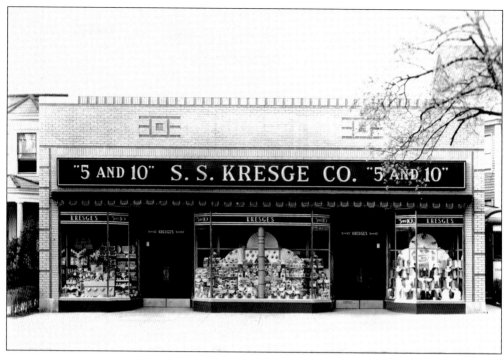

Another department store that was popular up to the 1970s in Albany was the five-and-dime store S. S. Kresge Company. This store was located on Madison Avenue next to the Ms. Madison Diner in the 1940s, near Allen Street.

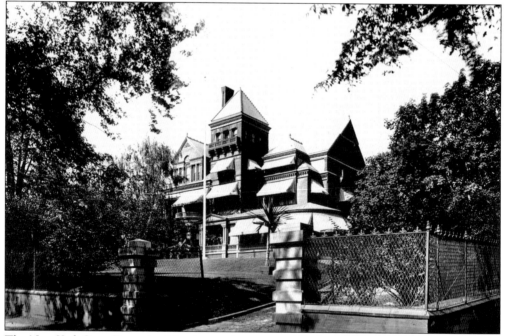

The New York State Executive Mansion at the corner of Eagle and Elm Streets is also known as the Governor's Mansion, although some governors of the state chose not to live there. It has been the home of 29 governors, the first occupying it in 1875. It has been remodeled several times.

The well lit tower of Albany City
Savings Bank on State Street on
February 23, 1929, was one the city's
skyscrapers. It was common to bath the
tower at night with floodlights.

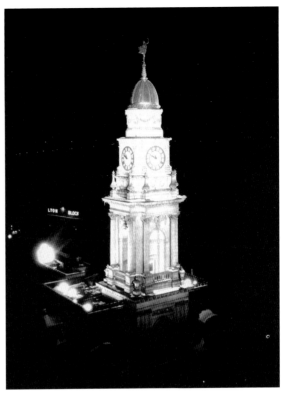

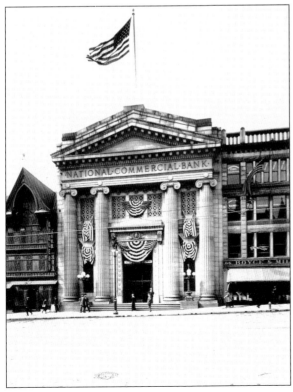

The National Commercial Bank
on lower State Street south side,
near State Street moved here in
1902. Next to the bank was Keeler's
Restaurant to the left.

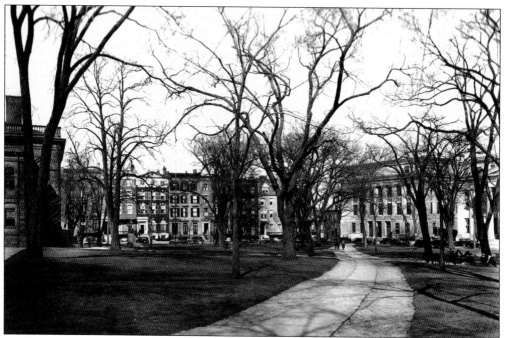

Academy Park is next to the old boy's academy that is still being used as offices. It was here, at the academy, that Joseph Henry taught physics and invented the electromagnet and telegraph in the 19th century. Henry became the first secretary of the Smithsonian and left a large mark on American science.

This is the Albany home of Henry at 105 Columbia Street. When he died in 1878, the entire federal government closed down. His boyhood home in Galway was razed or burned, and there is a historic marker on the site. This Albany house has been divided into two homes.

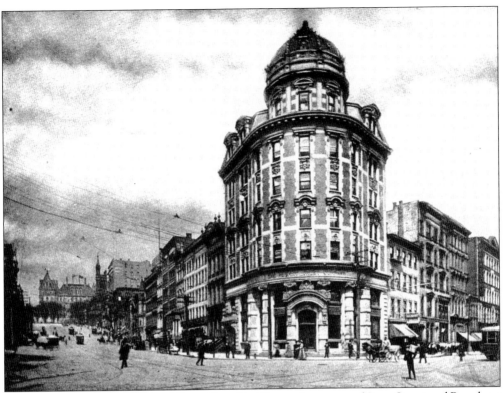

Here is an imposing view of the Albany Trust Building at the corner of State Street and Broadway in 1907. Beginning in 1904, the old museum building was remodeled by Marcus Reynolds, the same architect who designed the nearby D&H building.

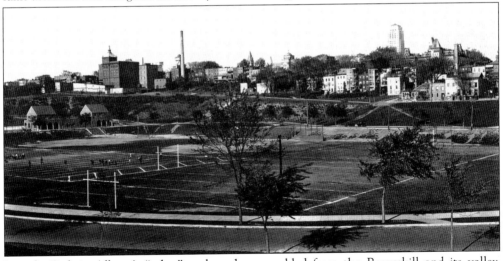

Lincoln Park is Albany's "other" park and was molded from the Beaverkill and its valley. Swimming pools and athletic fields were summer attractions for the kids and families. On the top of the park hill is the old laboratory of James Hill, the father of American paleontology and first state paleontologist of New York State, who was appointed New York State's geologist in 1892. The lab was a training ground for many geologists and still exists although used by a children's group.

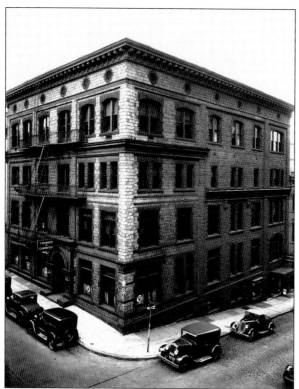

The Albany Chamber of Commerce building was located on the northeast corner of Maiden Lane and Chapel Street as shown here in this 1920s photograph.

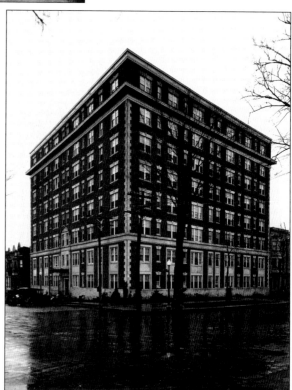

The Elouise Apartments at 11 South Lake Avenue on November 17, 1927, is one of the first uptown apartment houses and is located right across from Washington Park.

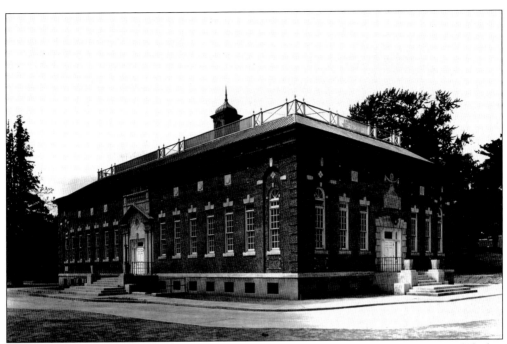

This is the Bleeker Stadium clubhouse. Bleeker Stadium once served as a water reservoir (Bleeker Reservoir) for the city's drinking water supply in 1852 and held 32 million gallons of water from the Pine Bush. It is one of the largest earthen construction structures in the world. It also was converted to a sports arena in 1930 and has seen baseball and football there.

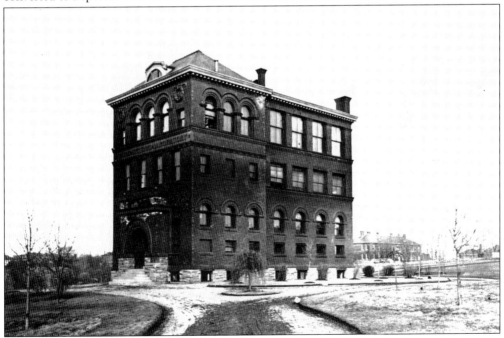

Bender Laboratory around 1940 was located just north of Dudley Observatory. In 1995, it marked a century of work in providing laboratory services to the Capital District. They are now associated with St. Peter's Hospital.

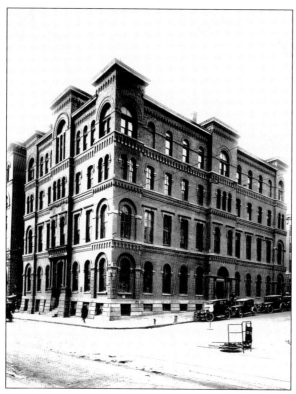

The Albany Public Building on the southwest corner of South Pearl and Howard Streets was built in 1868 and was also the site of the old center market. This building held the police, city courts, offices, and fire chief. It was also used as city hall when the new one (present) was being built.

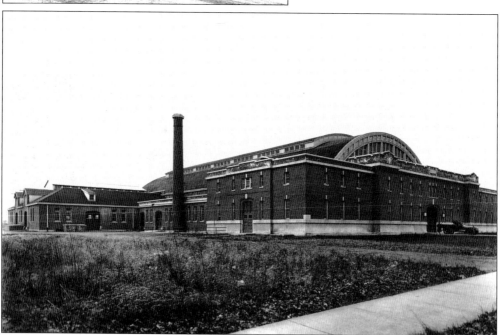

New Scotland Armory (Troop B) on New Scotland Road was built in 1914 and designed by Lewis Pilcher. It was added to the National Register of Historical Places in June 1991. Archeological excavations near it a few years later revealed that much of the area had been the burial ground for the poor and many bodies were exhumed.

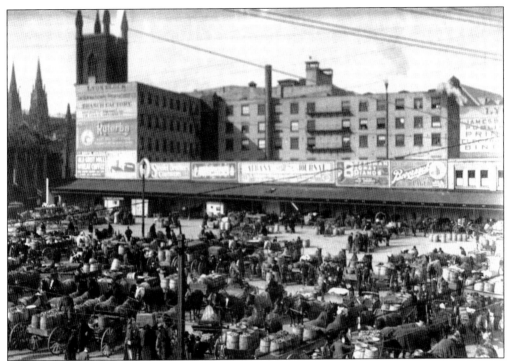

The Lyon Block at Hudson, Grand, and Beaver Streets in 1913 was the location of the farmers market and provided fresh food to all citizens. It was opened in 1889 and had 7,461 square yards of space.

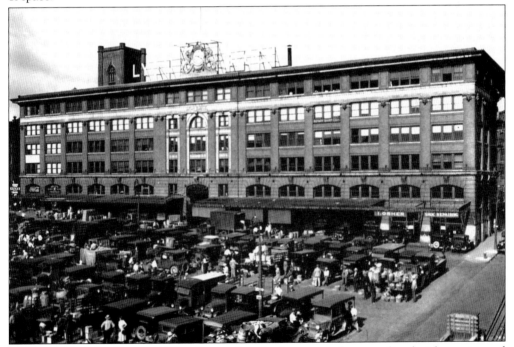

The Lyon Block building in 1912 still served as the farmers market, now lined with cars instead of wagons. This entire area is demolished and replaced with office buildings.

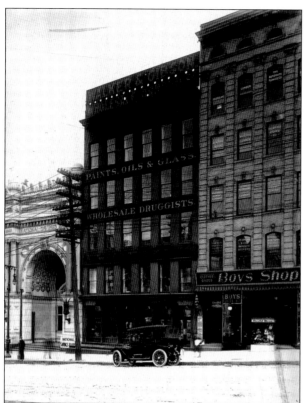

Erastus Corning was the first president of the National Savings Bank in 1868, as seen here in this 1920s view on State Street on the south side. The National Savings Bank building, far left, was built in 1902.

The Albany Hospital, seen here on New Scotland Avenue around 1900, became the Albany Medical Center and is one of the leading hospitals and medical research facilities in New York State. It was incorporated in 1898.

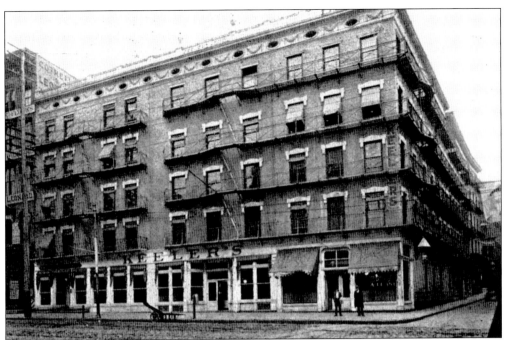

One of Albany's popular restaurants during the 19th century and early 20th century was Keeler's Restaurant located on Broadway and Maiden Lane. Unfortunately this building burned on June 17, 1919.

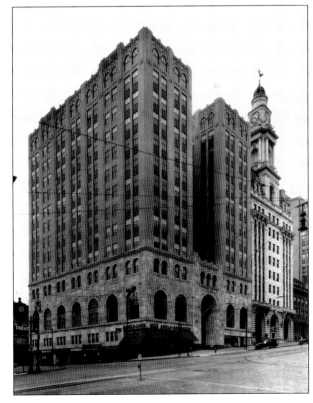

One of Albany's few skyscrapers in this 1920s photograph is the National Savings Bank building. It replaced a smaller office building known as the Arkay (R-K) Building.

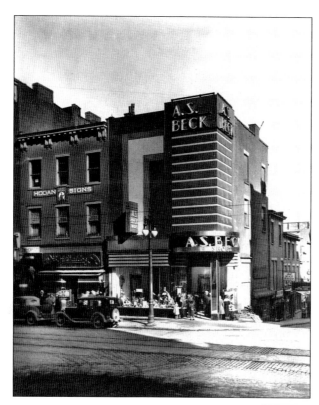

Shoppers found the A. S. Beck store on North Pearl Street during the Roaring Twenties a popular stop. Art deco style is coming in strong as can be seen on this building.

Built in 1892 and located at the intersection of Madison and Eagles Streets, the spires of the Cathedral of the Immaculate Conception are 210 feet tall. This photograph was taken in the 1920s.

The Ten Eyck Hotel boomed over Albany's skyline for many years. First as a smaller hotel just to the west of this building, then in 1915, the company built this imposing structure. It was torn down in 1971.

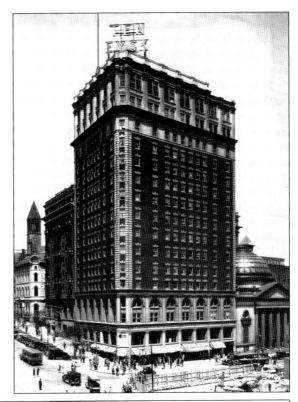

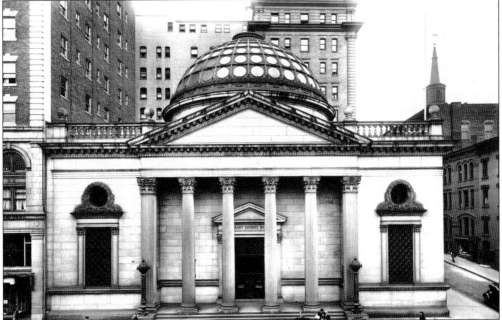

The Albany Savings Bank, with its beautiful dome and interior murals, was located on North Pearl Street and Maiden Lane but was torn down in the 1970s for a bus stop. Preservationists and the public were outraged and many who had savings in the bank withdrew their accounts. Albany Savings Bank was absorbed by Citizens Bank.

In 1894, this building was erected for the Independent Order of Odd Fellows, a fraternal group, at the corner of Howard and Lodge Streets. It burned to the ground on January 7, 1916.

Jack's Oyster House has been an Albany institution since 1913. Nothing much has changed since this photograph was taken in 1937 when they moved into this building. It is in the same building and has the same great food and service. Founder Jack Rosenstein was an oyster shucker for Keeler's.

Five

THE ALBANY SENATORS PLAY BALL

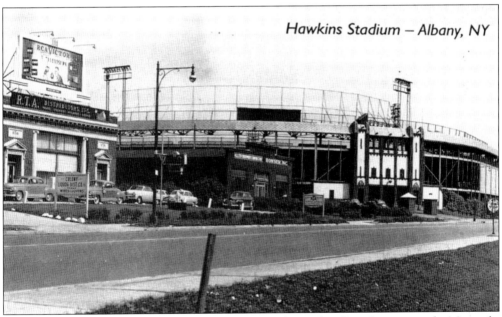

Hawkins Stadium, home of the Albany Senators, was located on Broadway in nearby Menands, a suburb of Albany on Broadway. Opened on April 18, 1928, the stadium was built at cost of $240,000 on site of old Chadwick Park, and it was called Chadwick Park until 1929. The Senators played ball for 75 years, from 1885 to 1959. They won pennants in 1901, 1902, and 1907 in the first New York State League, titles twice with flags in 1927 and 1929 in the old Eastern League, and another title in 1954 in the new Eastern League. Hawkins Stadium was sold to pay back taxes and razed in 1960.

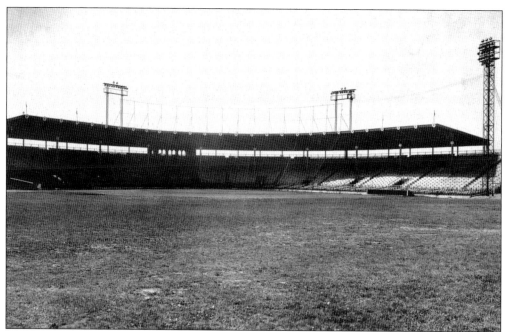

GE installed night lights at Hawkins Stadium in this view looking towards bleachers from center field on July 25, 1930.

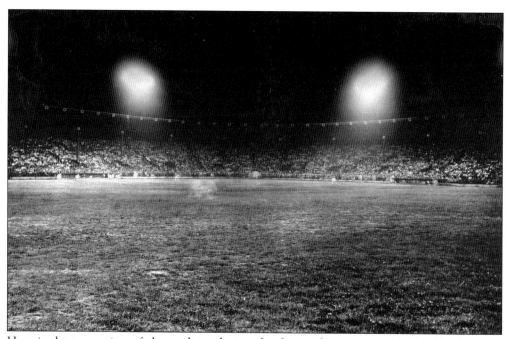

Here is the same view of the stadium during the first night game at Hawkins Stadium, on July 25, 1930.

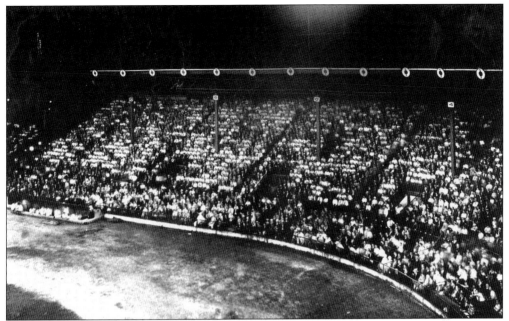

This is a close-up of the bleachers at the first night game on July 25, 1930, with an enthusiastic crowd.

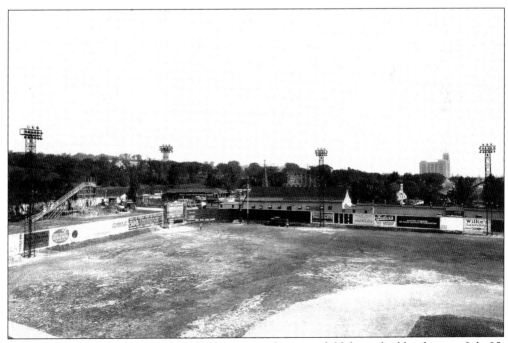

Here is a view of Hawkins Stadium looking towards center field from the bleachers on July 25, 1930, before the game.

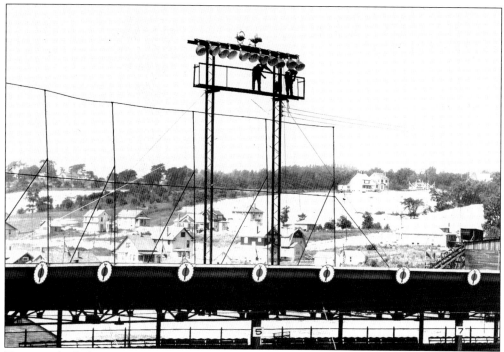

Here are the light towers showing the first lights (GE brand) at Hawkins Stadium on July 25, 1930, looking southwest.

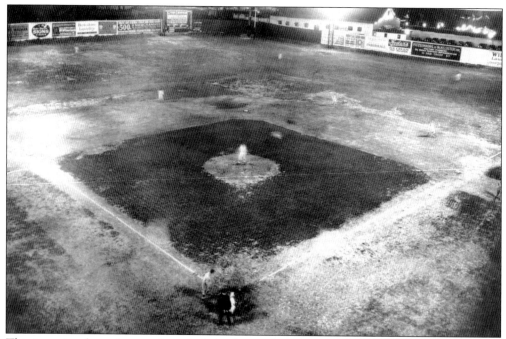

This is a view from the grandstand of the first night game underway at Hawkins Stadium on July 25, 1930.

Here is a view of one of the tower lights at Hawkins Stadium on July 25, 1930, that would light the field.

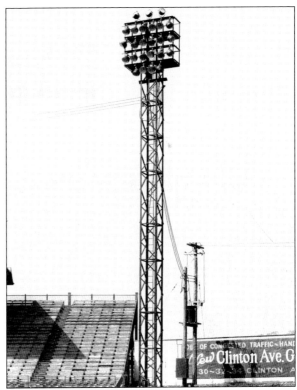

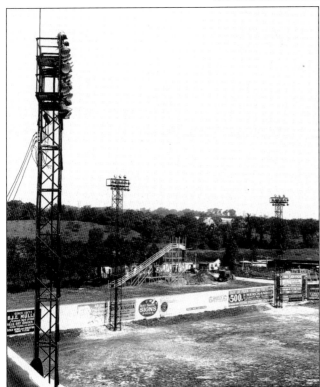

Here is a view of the towers taken from the roof grandstand at Hawkins Stadium, on July 25, 1930. Notice the small amusement park in the background.

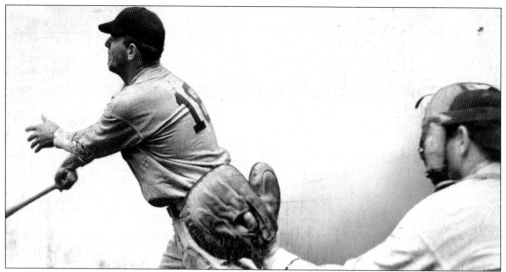

Bill Jackson and Harry Chozen (catcher) are seen in action here. Chozen, a catcher with 17 years in the minors, played only one game in the majors, on September 21, 1937. Chozen went to Albany in 1938, where he played in 107 games that year. In 352 at-bats, he batted for a .273/.291/.364 line, driving in 48 runs, and hitting five home runs. He was also the top fielding catcher in the league, with a .990 fielding percentage, which included only two passed balls in 97 games.

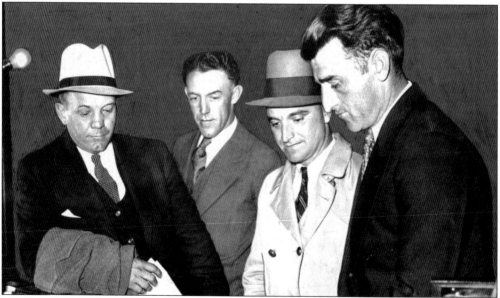

A group shot of the Albany Senators includes, from left to right, Gustaf Bernhard "Barney" Friberg (second baseman, third baseman, .263), Marty Callaghan, Harry "Jack" Seibold (pitcher), and Al Shealy (pitcher), on April 17, 1934. Outfielder Callaghan played for the Chicago Cubs in 1922, 1923, 1928, and 1930, with a .267 batting average. Seibold was purchased from the Boston Braves on June 16, 1933. He had pitched with the Philadelphia A's from 1916 to 1919 and the Boston Braves from 1929 to 1933. Pitcher Shealy played with the New York Yankees in 1928 and Chicago Cubs in 1930. Friberg was with the Chicago Cubs (1925), Philadelphia A's (1925–1932) and Boston Red Sox (1933). He led the National League in strikeouts in 1926 with 77.

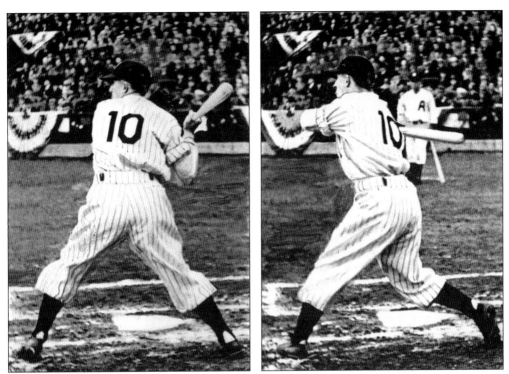

Albany Senator Lyle Judy played one year for the St. Louis Cardinals in 1935.

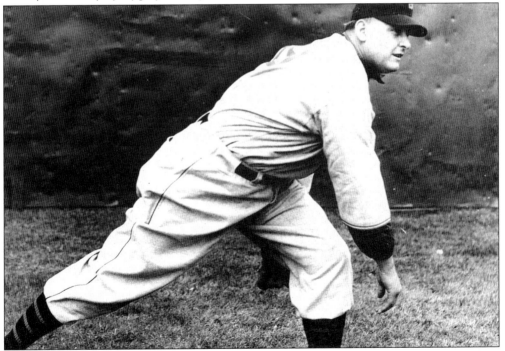

Bob Kline, shown here throwing against the Albany Senators at Hawkins Stadium on April 16, 1935, was a pitcher for Buffalo. Kline played for the Boston Red Sox (1930–1933), Philadelphia A's, and Washington Senators in 1934.

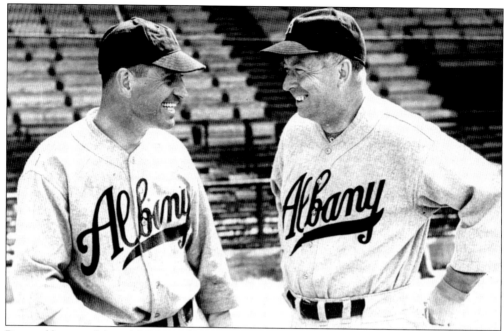

Pictured here are Marty McManus (infield) and Senators manager Bill McCorrey before a game. McCorrey managed the team in 1920, 1925–1932, 1933–1934, and 1937–1938. He pitched in 1933 and 1934. Infielder McManus played from 1920 to 1934 with the St. Louis Browns, Detroit Tigers, and Boston Red Sox, and was MVP ranked four times.

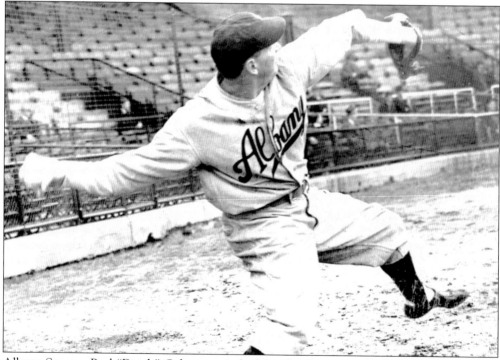

Albany Senator Paul "Dutch" Gehrman pitched for the Cincinnati Reds in 1937 (0-1). This photograph was taken in Albany on April 24, 1939.

This is a copy of the 1958 Albany Senators Baseball Club season card against Allentown.

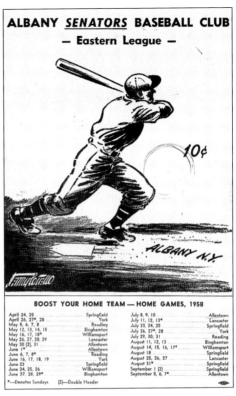

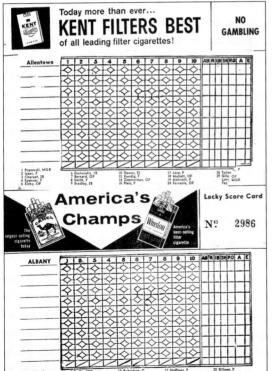

This is a photograph of the inside of the season card, where one could keep personal score of the game. Senators listed for the game were Schmidt, first base; Schmitt, pitcher; Valentin, infielder; Shea, infielder; Frulio, infielder; Brooker, outfielder; Abrams, infielder; Bawcam, infielder; Robertson, catcher; Wright, outfielder; Pfister, outfielder; Boxer, pitcher; Hoffmay, pitcher; Picker, pitcher; Sivlers, catcher; and Evans, manager.

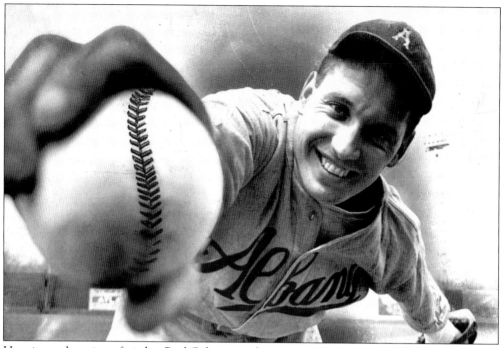

Here is another view of pitcher Paul Gehrman, who went to Cincinnati in 1937. Notable players for the Albany Senators were Rabbit Maranville, Ralph Kiner, Ripper Collins, Gus Bell, and Orie Arntzen.

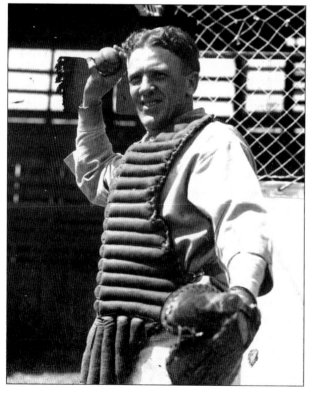

Albany Senators catcher Red Munn is shown here ready for action in 1932.

W. B. (Moore) Fuller, a pitcher who was nicknamed "Shorty," played shortstop in 1888–1896 with the Washington Nationals, St. Louis Browns, and New York Giants. He was the brother of Harry Fuller.

This photograph is labeled "Fuller, Pitcher 4/8/29," but is so far unidentified. He does look similar to Shorty Fuller, however. In 1929, Chadwick Park was renamed Hawkins Stadium. Under Bill McCorry, Albany won an Eastern League pennant. Albany players included future relief great John "Grandma" Murphy (8-4, 3.26 ERA) and Kewpie Dick Barrett (3-2, 3.48 ERA). John Gill led the Eastern League with 150 runs scored and 232 hits, and Moses Solomon hit .307 in 41 games.

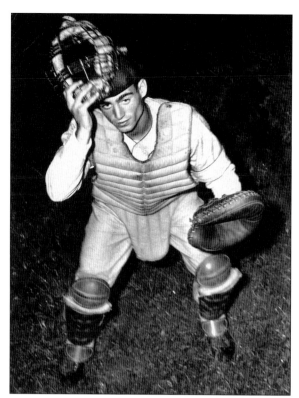

Tony Curro was a catcher with the Albany Senators in this undated photograph.

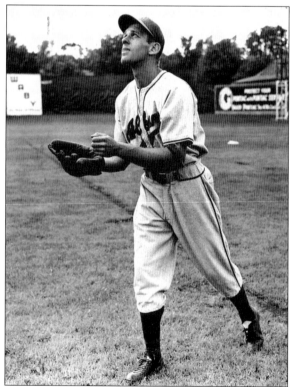

This photograph of Albany Senator Bill Garbe was taken on June 26, 1948, and it appears that he is an outfielder by this pose. That year, the Albany Senators reached their peak attendance, 210,804. Fred Lanifero led the Eastern League with 169 hits.

This photograph is labeled "Heald, 1930," but so far is unidentified; all that is known is that he is an Albany Senator.

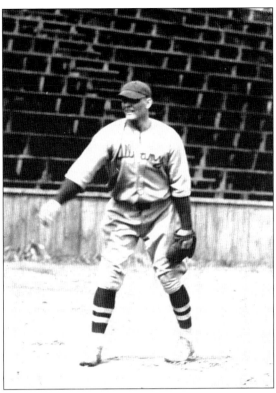

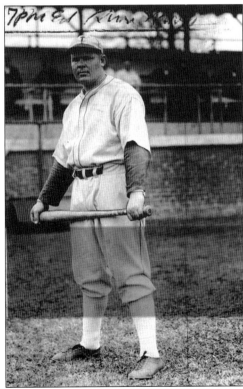

This photograph is labeled "Howell, Outfield," with no date, so it is another unidentified Albany Senator who needs his history told.

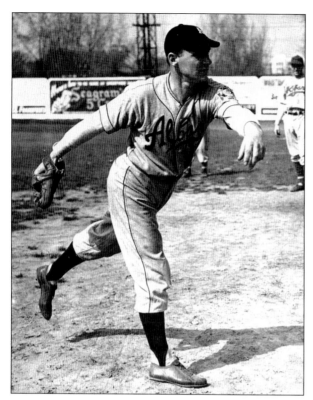

This is another photograph of an Albany Senator, labeled "Hvisdos" with no date, so little is known about him (except that he is a pitcher).

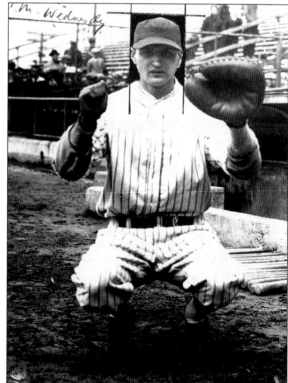

William John "Hank" Karlon played left field and was a catcher for the Albany Senators in this photograph dated April 29, 1931. He played with the New York Yankees in 1930 as an outfielder.

Here is another view of Karlon, outfielder, third baseman, and catcher for the Senators, in this photograph taken on April 27, 1932.

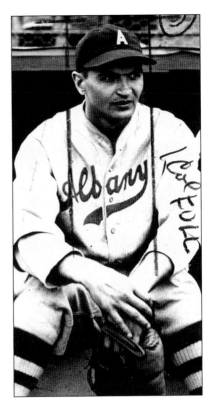

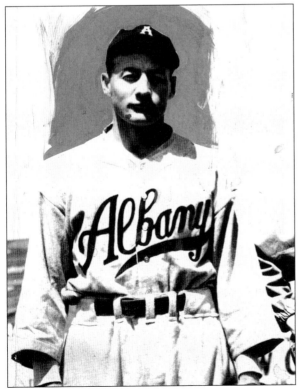

Les Horaw (or Horan) played right field for Albany in this undated photograph.

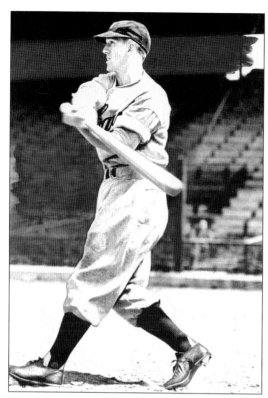

Lyle Leroy "Punch" Judy played second base for the Albany Senators and played one year for the St. Louis Cardinals in 1935.

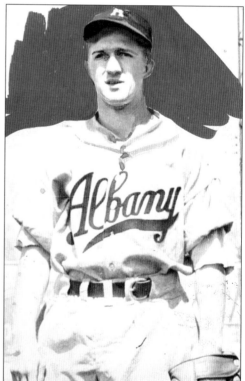

This is another view of Judy who played second base for the Albany Senators.

Marty McManus played third base for the Albany Senators in this photograph dated May 12, 1939. In 1939, the Brooklyn Dodgers visited Albany and coach Babe Ruth hit his last homer ever in the majors.

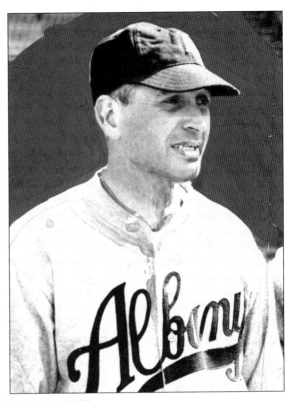

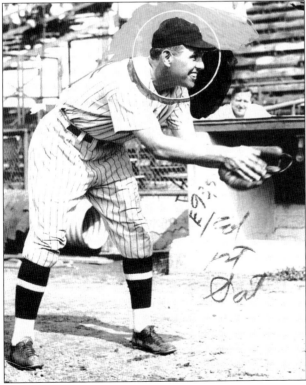

This Albany Senator Joe Maury (there is no date on the photograph) appears to be an infielder for the Senators.

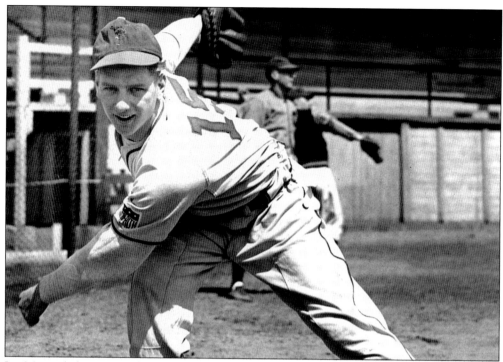

Joe Menarchek was a pitcher in 1939 for the Albany Senators. Rabbit Maranville managed the Albany Senators that year, and they earned a fourth place finish.

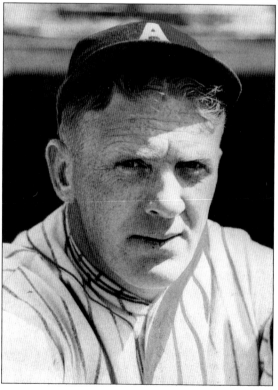

This is a photograph of Senator Red Munn on May 4 (no year).

This is a photograph of Senator outfielder Jim Moore, who played with the club in 1933. Moore pitched from 1928 to 1932 for the Cleveland Indians and Chicago White Sox. He had a 2-4 record.

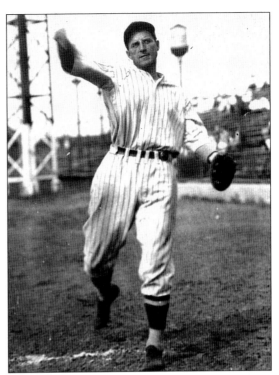

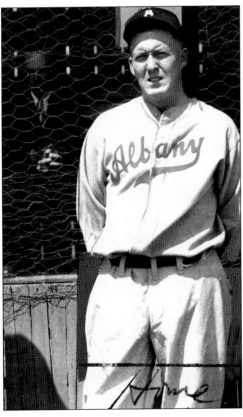

Little is known about Albany Senator Jim Murphy, pictured in this undated photograph.

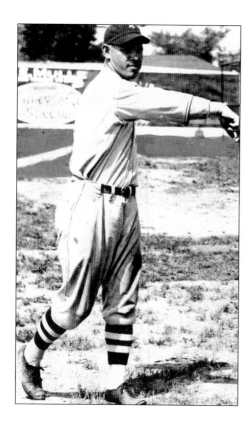

Albany Senator Chuck Outen is shown here in this 1930 photograph.

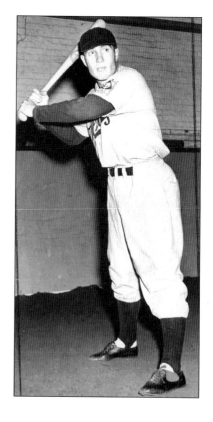

Another Albany Senator, Mel Preifisch is shown in a batting stance on April 22, 1940. That year, Albany's Kermit Lewis earned a .325 average. He led the Eastern League with 86 runs, while Bill Sodd led the Eastern League with 88 RBIs and Virgil Brown led the league with 22 wins.

This is an undated picture of Albany
Senator Don Robinson.

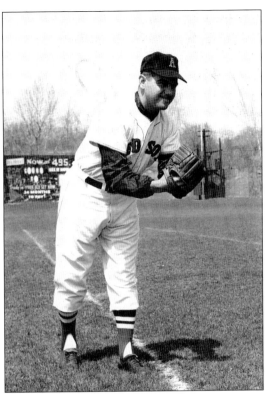

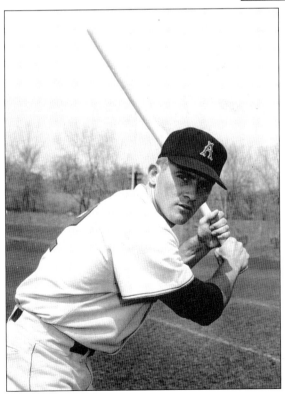

This undated picture is of Rusty Ruige,
catcher for the Albany Senators.

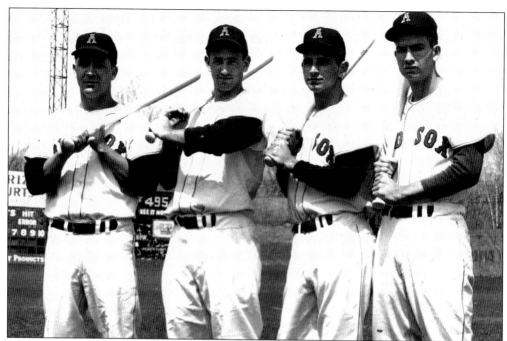

These Senators are, from left to right, Hal Rudwallsen, Bob Fuller, Lueren Clinton, and Jack Brown, when Albany was a Boston Red Sox affiliate during 1952–1953 and 1955–1959.

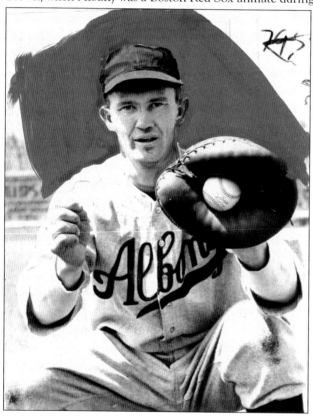

Albany Senator catcher Jim Reilly is shown in this picture that has no date.

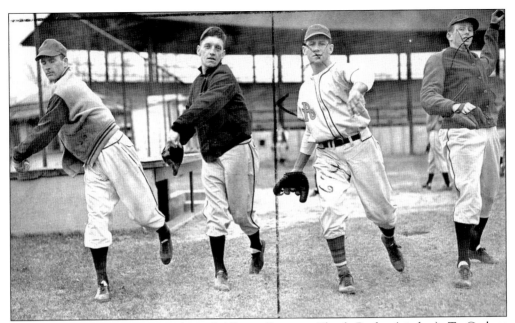

From left to right, this group shot of Albany Senators Chuck Rushe (pitcher), Ty Corbett (pitcher), Sal Cuttrila, and Paul Wright was taken on April 6, 1946. Corbett signed with the Pittsburgh Pirates (Albany was their farm team) in 1942. He played with Albany in 1943 and had a 5-4 record and a 1.96 ERA. He was also used in the outfield because of his strong hitting. Hall of famer Pie Traynor referred to him as the best amateur player he had ever met.

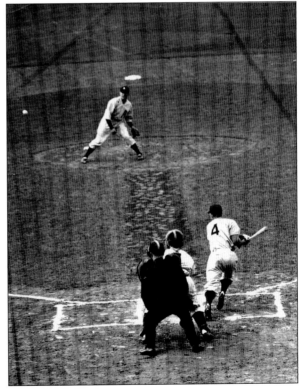

Lyle Judy takes a swing in the Albany Senators winning year of 1949.

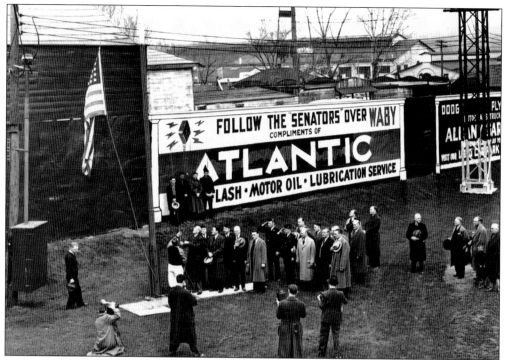

This view shows Mayor John Boyd Thatcher raising the flag at a game at Hawkins Stadium on April 27, 1939.

Here is a view of members of the team on the bench during a game on May 1, 1945.

Here is a shot of the Albany Senators celebrating their win on April 20, 1948, but they lost the league finals. On August 12, 1948, before 6,410 fans, the Senators lost 5-2 to the Philadelphia A's.

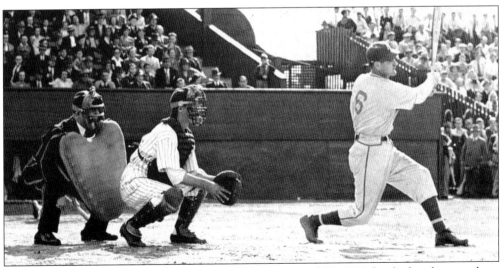

This photograph is labeled "Snyder" and was taken on April 30, 1942, but little is known about this Albany Senator.

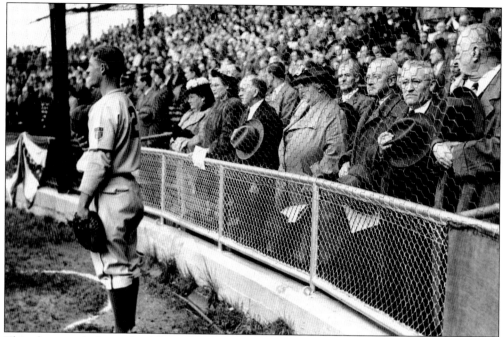

This photograph shows the Albany Senators ready to play ball on May 3, 1945. Those in the first row of seats are probably local dignitaries.

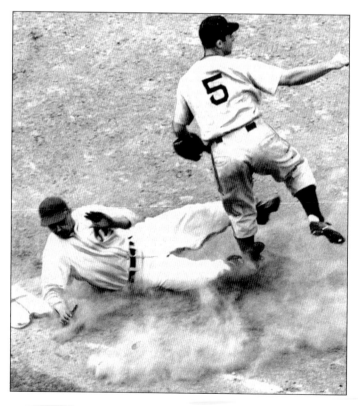

Here is a view of opening day, Binghamton versus the Albany Senators, on April 24, 1941. On April 23, Ralph Kiner debuted for Albany. He went on to bat .279 with 11 homers and 66 RBI in 141 games.

Here is a view of Binghamton and Albany playing a game on April 24, 1941, opening day. A man identified only as Gamelli is the catcher, and Art Gore is the umpire.

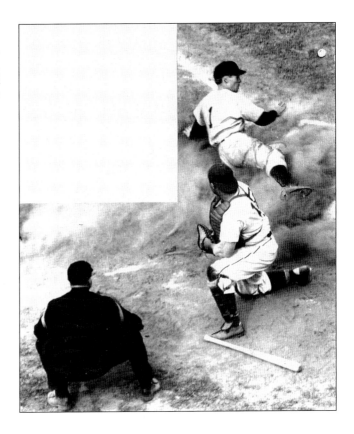

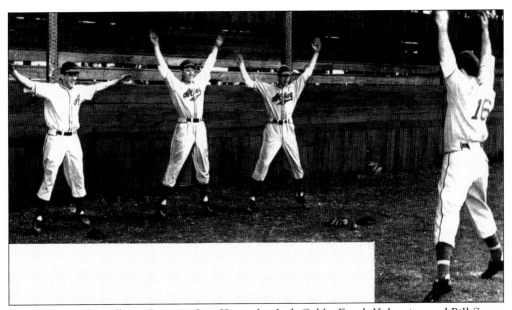

From left to right, Albany Senators Len Kensecke, Jack Cable, Frank Kubowies, and Bill Street are shown here working out.

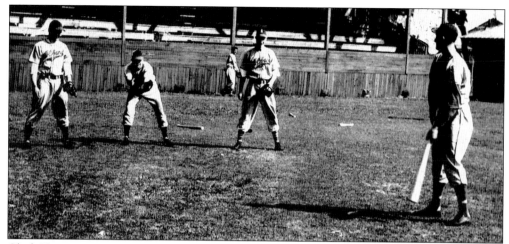

Clark Henry, veteran outfielder, wields the bat in this pepper game, a traditional part of baseball warm-ups. From left to right, Bill McLaren, B. B. Williams, and Jimmy Cullinane are on the receiving end in this workout, which marked the first drill on March 18, 1948.

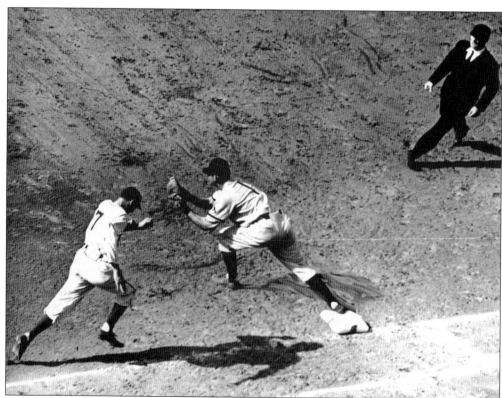

A player identified only as Webster is "out at first" in this Utica versus Albany contest on September 17, 1945. In 1945, Albany's Fred Clemence led the Eastern League with 23 wins.

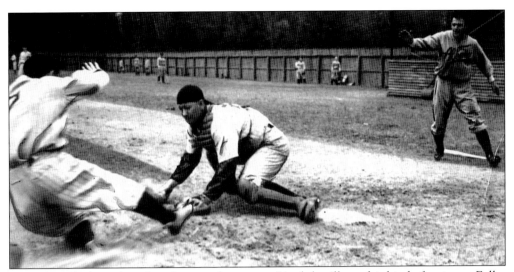

According the legend on this photograph it states, "And they'll see this kind of action at Fuller Park, Barnwell S.C. where Albany teams also trained in 1934, 38 and 39. The photograph was taken during an intra-club game last spring shows Wayne Blackburn sliding home with Walter Stephenson catching and Bill Jackson looking on. None of the trio is with the Senators this spring." The date of the photograph is March 22, 1940. Wayne Blackburn was an infielder from 1936 to 1956, all in the minor leagues (1936–1944, 1946–1954, 1956). He lost one year to the military, and he was inactive for one year. Until 1968, he continued as a minor league manager and major league coach. Walter "Tarzan" Stephenson was a catcher from 1935 to 1937 for the Chicago Cubs and Philadelphia Phillies.

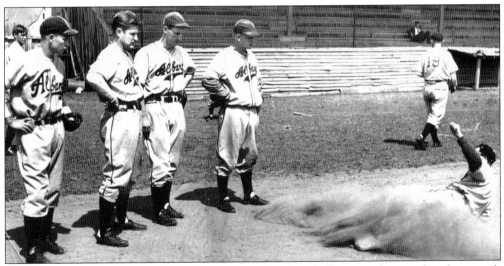

Practicing the slide is one of the basic fundamentals of baseball, as seen here in this photograph taken on April 14, 1942. On August 5, 1942, Satchel Paige appeared at Hawkins Stadium and announced his feeling that blacks integrating into major league teams "would cause friction." He said, "I'd rather see an entire Negro team represent some city in the league. That way the racial problem would be more or less eliminated."

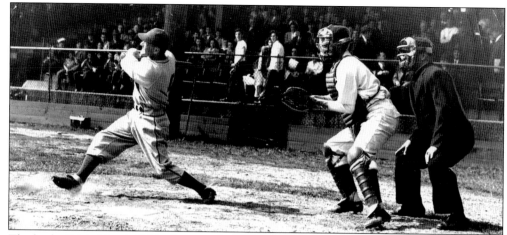

The back of this May 4, 1944, photograph says, "Bill Lezansky of Albany swings at the opening pitch of the Eastern League campaign yesterday in Hartford." The catcher is a man identified only as Brady and the umpire, identified only as Moore, is behind the plate. That year, Albany player-manager Ripper Collins hit highest average in organized baseball, .396. He also led the Eastern League with 40 doubles, while Vic Barnhart led the league with 115 RBIs. Albany's Al Gionfriddo hits 28 triples, the highest total in organized baseball that season and still the Eastern League record.

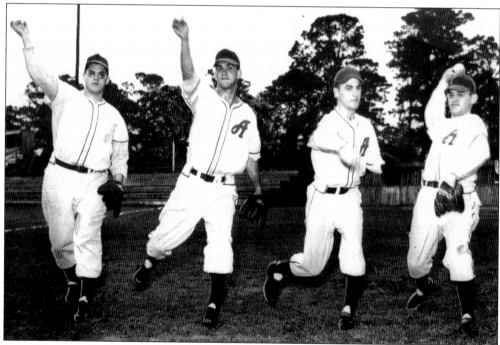

From left to right, Albany Senators Ed Kalski (Cohoes), Jack Bumgarmer, Bob Samsel, and Dutch Gottschall pose for the camera on March 18, 1948.

Six

INTERIORS

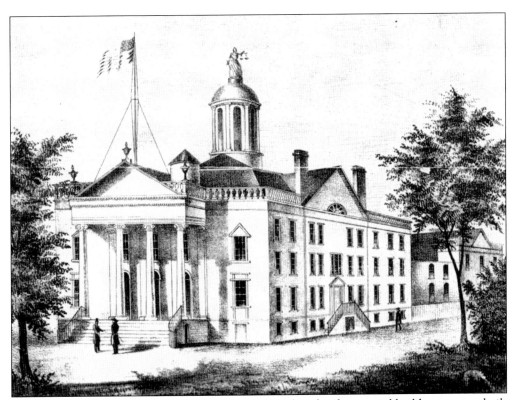

Albany became the capital of New York State in 1797 but this first capitol building was not built at the corner of State and Eagle Streets until 1806 by the citizens of Albany and stood until 1883. It was located just southeast of the present capitol building.

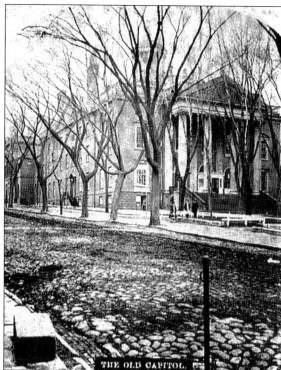

This is a rare photograph of the first state capitol building, around 1880. This was replaced by the present capitol building. Previous to the erection of this building, the legislature met in Poughkeepsie, Kingston, and New York City before the legislature passed a law in 1786 declaring its home should be the last place it met—in this case Albany.

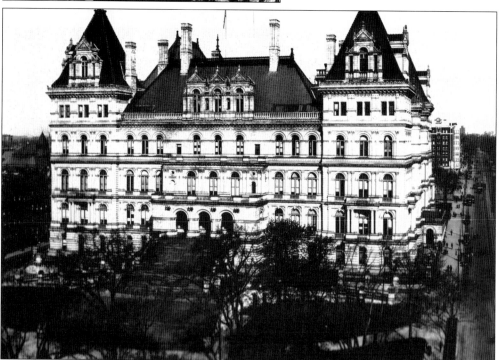

Seen here is the present capitol building that was constructed between 1867 and 1899 and inspired by the Hôtel de Ville (City Hall) in Paris, France. It cost $25 million (or half a billion in current dollars) and was the most expensive government building of its time.

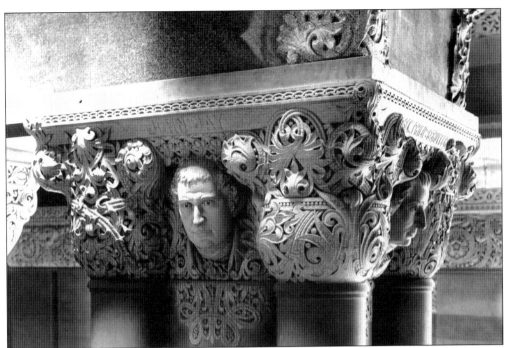

Here is a close up of a stone pillar and capital showing intricate designs and head figurines in the capitol building. The building was declared a national historic landmark in 1979. The building is constructed in both Romanesque and Renaissance styles.

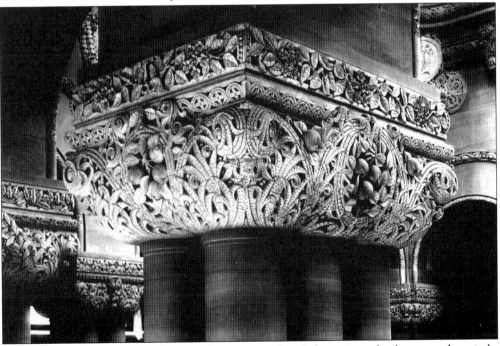

This is another photograph showing the intricate detailed carving of columns and capitals. Three teams of architects designed the building: Thomas Fuller (1867–1875), Leopold Eidlitz and Henry Hobson Richardson (1875–1883), and Isaac G. Perry (1883–1899).

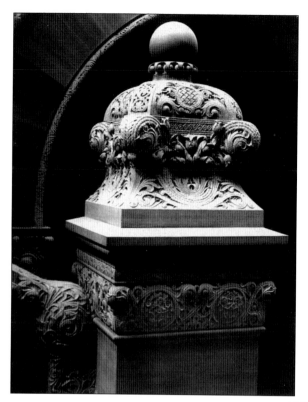

This stone newel atop the stairs is also intricately carved in the capitol building. The building's exterior is made of white granite from Hallowell, Maine, and the building incorporates marble cut by state prisoners at Sing Sing.

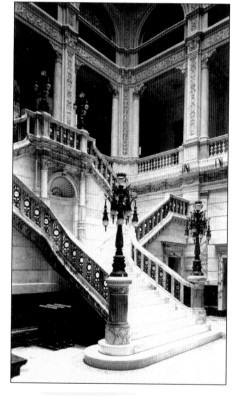

Here one can see one of the many staircases in the capitol building as it looked on May 19, 1903, before the great fire of 1911. In 1865, a legislative act authorizing construction of new capitol building passed, and it took 25 years to build.

Here is another view of staircases and detail in the capitol building before the fire of 1911. Notable architectural features include its interior "million dollar staircase" and massive, 166-foot-long exterior "eastern staircase." The million dollar staircase, or "great western staircase," is the largest in the building.

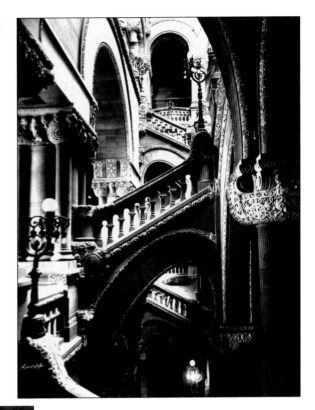

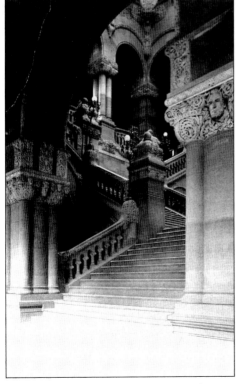

The great western staircase, or million dollar staircase as it was called, is seen from below in 1907 before the fire. In 1871, the cornerstone of the present capitol building was laid. In 1896, the great western staircase was completed with installation of a skylight.

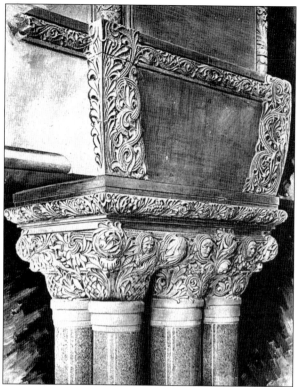

This photograph was taken to show another detail of one of the capitals in 1907. In 1891, work began on the eastern approach, the capitol building's great exterior staircase. To complete this complex staircase, 600 stone carvers were employed to carve the structure by hand.

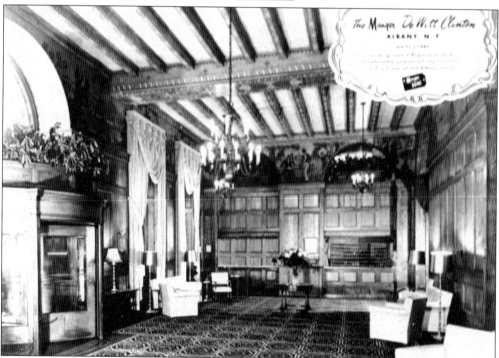

The interior lobby of the DeWitt Hotel is shown here when it was one of Albany's premier hotels for a century. It is now being used as housing for college students.

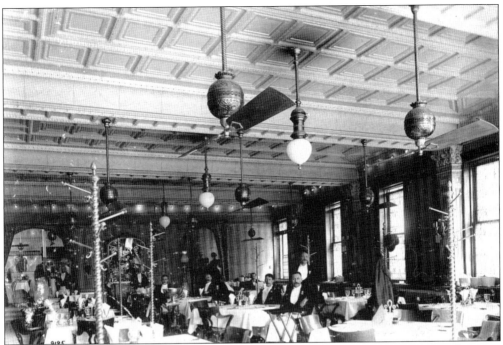

Here is a rare view of the inside of Keeler's Hotel and Restaurant on Broadway and Maiden Lane during the 1890s. It was a popular spot for many years until June 17, 1919, when it completely burned in two hours. While most people were able to get out, the fire did kill one person.

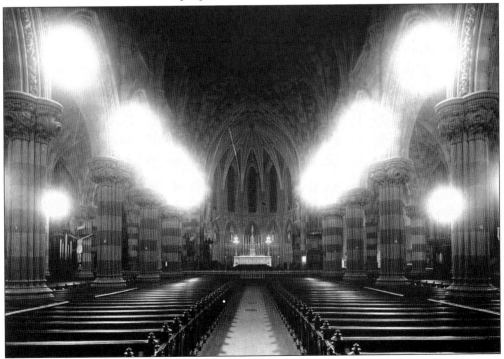

This is a rare view of the interior of the Cathedral of the Immaculate Conception applying electric lights for the first time in 1918.

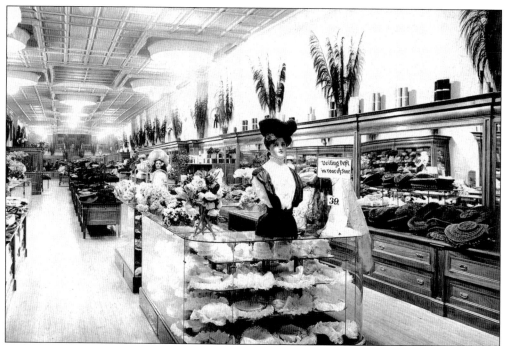

The inside of the Simon Stahl Millinery Store on July 7, 1917, was promoting the use of electric lights in this photograph. Gas lighting was a poor source of lighting, and it left soot on clothes. Many shopkeepers welcomed the use of electric lighting to remedy this.

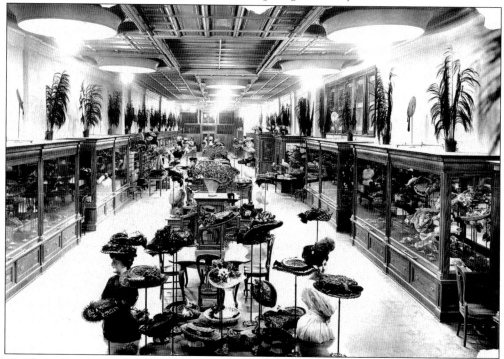

This is another view of Simon Stahl Millinery Store showing how electric lighting brightened up the store.

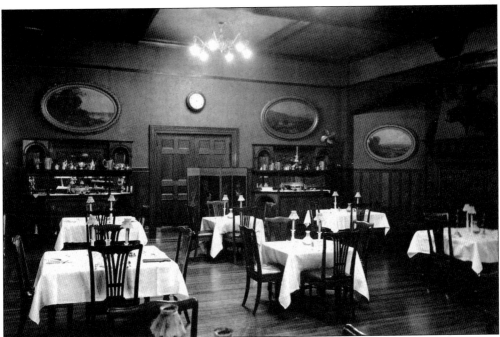

Here is a rare view of the inside the dining room of the Fort Orange Club located on 110 Washington Avenue. This private men's club was opened on July 1, 1880. Its membership has included Presidents Grover Cleveland, Ulysses S. Grant, Theodore Roosevelt, and Franklin D. Roosevelt. This photograph is dated March 24, 1904.

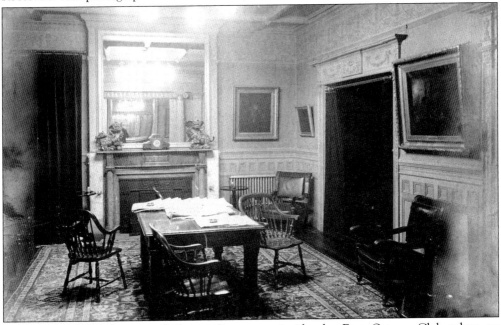

This is another rare view of the reading room inside the Fort Orange Club taken on March 24, 1904. Imagine Franklin D. Roosevelt or Ulysses S. Grant sitting here reading the newspaper of the time. Theodore Roosevelt was president at this time, and the United States population was a little more than 82 million.

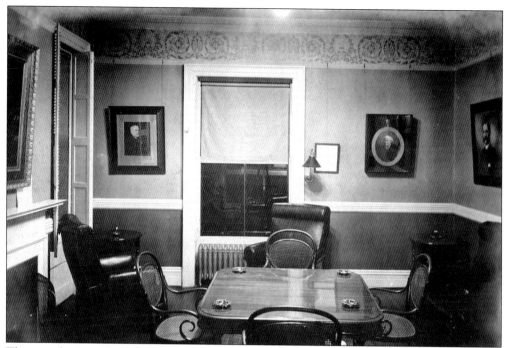

This is a photograph of the President's Room of the Fort Orange Club on March 24, 1904. The World Series was not played in 1904, and the subway in New York City opened for the first time. It cost 2¢ to mail a first class letter.

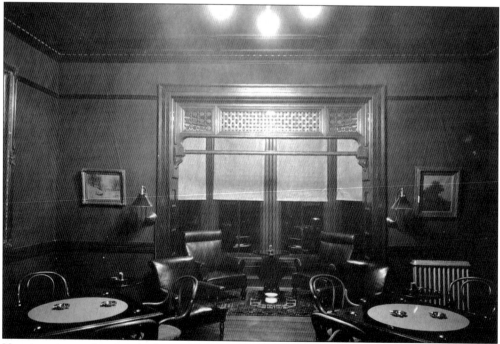

Here is a picture showing the Lounging Room at the Fort Orange Club on March 24, 1904. This was the year that the Russo-Japanese war began and was sure to be a topic of conversation in this room. It was also the year we began construction of the Panama Canal

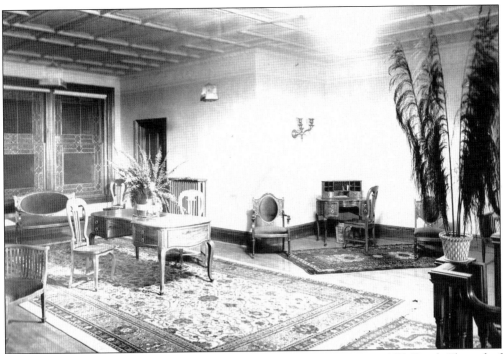

This is a rare inside view of Simon Stahl's office on July 7, 1917. In 1905, Frank Elmendorf entered the employ of Stahl as superintendent in the millinery business and was continued in that capacity when the business was sold to Jonas Muhlfelder.

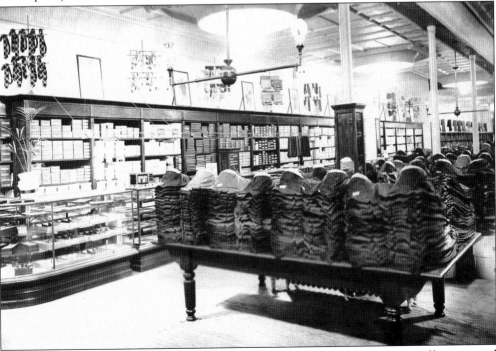

Here is another inside view, this one of Babbitt's Clothing Store showing dozens of hats, around 1920. The 1920s were not called the Flapper era for nothing.

ACROSS AMERICA, PEOPLE ARE DISCOVERING SOMETHING WONDERFUL. THEIR HERITAGE.

Arcadia Publishing is the leading local history publisher in the United States. With more than 3,000 titles in print and hundreds of new titles released every year, Arcadia has extensive specialized experience chronicling the history of communities and celebrating America's hidden stories, bringing to life the people, places, and events from the past. To discover the history of other communities across the nation, please visit:

www.arcadiapublishing.com

Customized search tools allow you to find regional history books about the town where you grew up, the cities where your friends and family live, the town where your parents met, or even that retirement spot you've been dreaming about.